# IMAGES of America
# LOST FARMS OF THE ST. CROIX VALLEY

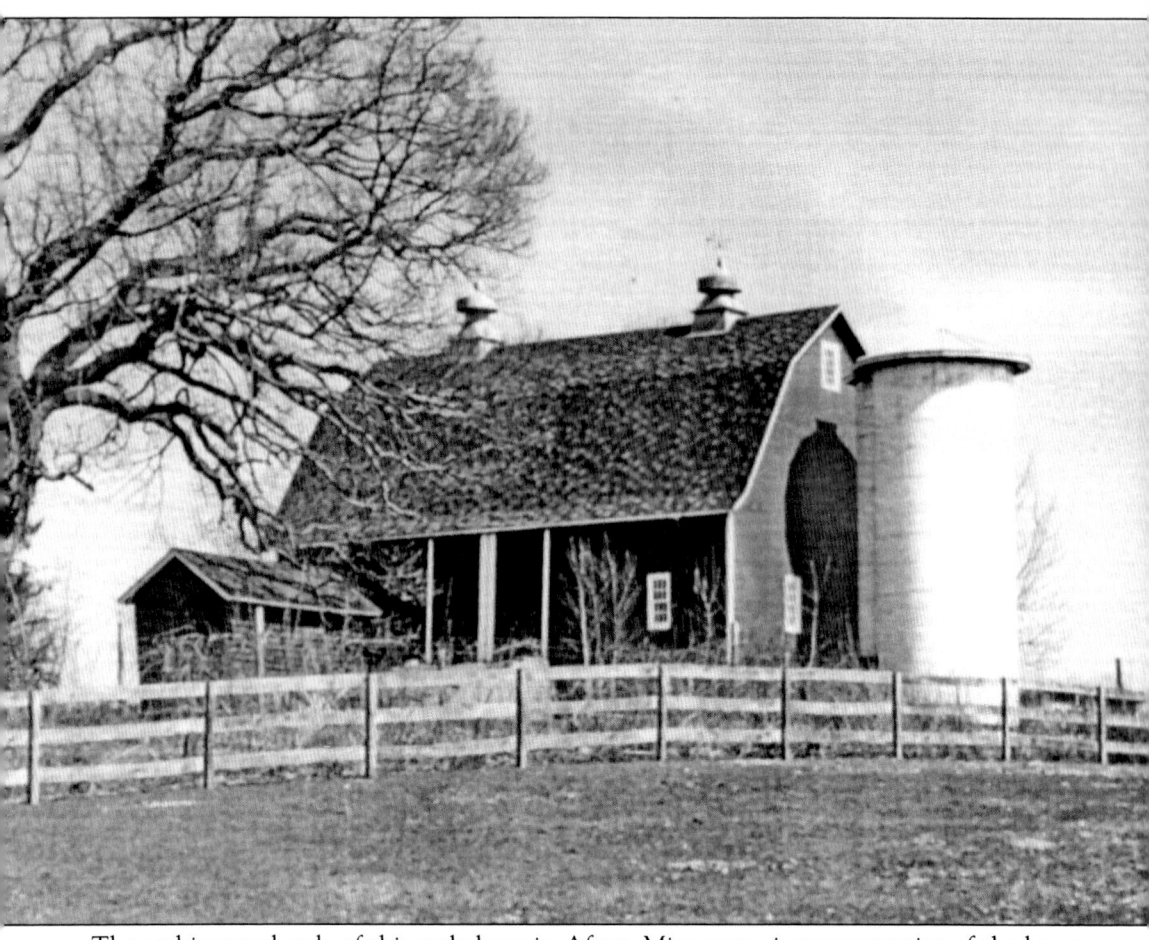

The architectural style of this early barn in Afton, Minnesota, is representative of the barns throughout the St. Croix Valley. This style maximized space for livestock and feed storage. With the advent of modern agricultural technology, barns of this kind are no longer practical. Many have been abandoned or torn down, and soon, this type of barn architecture will be lost. (Courtesy of the Afton Historical Museum.)

ON THE COVER: Berry pickers from Afton pose for a photograph in the field. Agriculture has always affected the local economy, shaped the valley's culture, and influenced the development of and camaraderie in communities. For more information on the Brigg's Produce Farm, see chapter eight. (Courtesy of the Afton Historical Museum.)

IMAGES
*of America*

# Lost Farms of the St. Croix Valley

Kristina Boucher

Copyright © 2017 by Kristina Boucher
ISBN 978-1-4671-2513-0

Published by Arcadia Publishing
Charleston, South Carolina

Printed in the United States of America

Library of Congress Control Number: 2016953991

For all general information, please contact Arcadia Publishing:
Telephone 843-853-2070
Fax 843-853-0044
E-mail sales@arcadiapublishing.com
For customer service and orders:
Toll-Free 1-888-313-2665

Visit us on the Internet at www.arcadiapublishing.com

*This book is dedicated to the Boucher family and the Village View Dairy Farm in East Farmington, Wisconsin. The memories created there are what inspired this book.*

# Contents

Acknowledgments 6
Introduction 7
1. Geological History 9
2. Early Pioneers 19
3. Government Influence 41
4. Logging Industry 55
5. Wheat Boom 65
6. Growing Communities 83
7. Dairying and Berries 91
8. Farming Today and Preservation Efforts 113

# Acknowledgments

I would like to give many thanks to all the people who have made this book possible. Writing is not an independent endeavor, and I am truly grateful to everyone who supported me during this entire process.

First, I would like to give a special thanks to my Uncle Mike for all his help and farming knowledge. All BS aside, this farmer really knows his sh*t.

I would also like to thank my parents, Scott and Shannon, and grandparents Gayle and Kevin for being so supportive during this process. A special thank-you goes to my Grandma Gayle for driving me all over the countryside barn hopping; those are cherished memories.

I would like to thank the Afton Historical Society for going above and beyond with its historical knowledge and assistance—I cannot thank them enough.

Lastly, I would like to thank all of the farmers and their families for taking time out of their day to reminisce with me about how things used to be. It is an honor to share your stories, and this publication would not be possible without you.

# Introduction

The *Baldwin Bulletin* shared the following staggering statistic from the National Agricultural Statistics Service: each day in 2016, Wisconsin lost an average of one dairy barn. When driving down the back country roads in the St. Croix Valley, this statistic truly does hit close to home. When evaluating different reasons for our disappearing farms, it is often difficult to pinpoint just one. The *Baldwin Bulletin* identified one overarching reason: the price of milk has fallen below the cost of production. If any other business was operating in a deficit it would no longer be in operation, but for farmers, this is just the way it is. While both large and small farms are affected by this deficit, it is the small, traditional family farms that are suffering the most. Those gorgeous old red barns are falling to the wayside, a pitiful reminder of our region's prosperous agricultural background.

After the American industrial revolution and the Great Depression, traditional agriculture took a hit. The way America chose to feed Americans was forever changed. The change just moved so slowly that many people failed to notice. Wisconsin and Minnesota still rank fairly high in the number of total farming operations, Minnesota being eighth in the nation and Wisconsin tenth, according to the National Agricultural Statistics Service. However, these numbers are steadily decreasing. Local farming unions are working to assess the needs of farmers during this crisis, but it is evident that awareness and action has arrived too late.

When interviewing one Wisconsin farmer on the state of this region's barns, he simply said, "It only takes a year. If there's no animals in the barn, there's nothing in there to keep the barn alive. It'll just fall apart." There is certainly a blend of beautiful and eerie rhetoric behind his statement. There is a correlation between keeping animals in a barn and its condition—even without leaning on the superstitious side—but who are we to judge over a century's worth of St. Croix Valley farmers' logic?

Not all of our barns have been left to crumble. There have been strong movements toward barn restoration. Some tackle the restoration projects independently, such as the Lindstrom Round Barn near St. Croix Falls, Wisconsin. The barn was built in 1913 but was left abandoned for a number of years until a Minnesota resident purchased it in the early 2000s. He worked to maintain and update the old white pine boards that were rotting and placed an array of multicolored shingles to prevent the roof from leaking. The wall itself was beginning to bow, and he self-rigged ropes and pulleys to straighten out the walls once again. Despite his efforts, just this year he realized the barn roof had sprung another leak—one that was debilitating enough to soak all the way through to the basement. The cost of repairs is over $10,000. The project is at a standstill.

There are promising stories of preservation as well. Grants have preserved a crumbling barn's foundation. Historic preservation groups have returned barns and silos to their original vigor. The National Register of Historic Places has helped put old farms in the limelight, reminding Americans that these old places are worth preserving. Still, that unforgiving statistic weighs heavily upon this region. It is not just a farm a day—it is history, families, and memories, all disappearing.

The majority of barns that remain in this region are of the Wisconsin dairy barn style. This style can be credited to the large number of German settlers who arrived in the St. Croix Valley in the mid-1800s. The traditional German dairy barn was built into a bank, thus creating a basement level for housing livestock and an upper level for storing feed. When Germans arrived in this region, they found that the hills and banks required to build their barns were not as common as in their native homeland. An innovative barn style to meet their demands was created: a large gambrel roof optimized second-floor storage, and a long, rectangular ground-level floor housed larger amounts of dairy cattle. This style of barn also has a mix of features such as roof ventilators, dormers, and a multitude of windows. This practical barn style is seen quite often throughout the St. Croix Valley and has spread throughout the nation.

Today, any new barns that are built will not use the creative ingenuity of the Wisconsin dairy barn. A less-expensive and more easily built and maintained style has taken hold: the pole shed. While pole sheds lack the architectural beauty of traditional barns, modern-day farmers find them more suitable for housing larger amounts of livestock and modern farm equipment.

Research and interviews of local farmers have pointed to several reasons why our region's barns are disappearing. The aforementioned problem of modern farmers operating in a deficit certainly ranks high. However, many farmers also seem frustrated with the wildly fluctuating milk prices. A large farm can accommodate price changes by controlling output; that is, they can milk more when prices are high and store milk when prices are low. Small family farms, the most common in this region, are not able to accommodate fluctuating prices. The worldwide monster of agricultural supply and demand tends to prey on the more vulnerable ma-and-pop farms, those that built American agriculture in the first place.

This tangled web of supply and demand is not the only issue that St. Croix Valley farmers face. One local farmer simply stated that she had "run out of farmhands that were willing to help." Historically, the hired man was an integral part of operating a farm. In the late 1800s and early 1900s, these men were often wanderers or new to the region, and looking for an intermediary step between pioneer and landowner. As America's economy shifted and more people transitioned from agricultural to industrial work, more people opted to find jobs in the cities, and in the St. Croix Valley, that meant traveling to Minneapolis or St. Paul to work in the factories. A lack of hired hands made farming too strenuous for some families, and they either chose to downsize or sell their farms.

As our region's farmers grow older, we are facing yet another roadblock. There are fewer and fewer young adults who choose to continue farming. With no one to inherit the farm, many are put up for sale. According to the US Department of Agriculture, the number of farmers over age 65 is up to 22 percent. To shed even more light on our aging farmers, for every five farmers over the age of 75, there is only one under the age of 25. Young people are seeing farming as isolated, grueling, low-income work; essentially, feeding America is no longer an attractive option for today's children.

It also does not help that our middle-aged farmers' ears may still be ringing from the farm financial crisis of the 1980s, yet another depression that severely affected America's farmers. It is no question that farmers are a tough breed. It is a 365-day-a-year job, with no weekends, no holidays—it is a life dedicated to the trade. And it seems as though every time our economy shakes, farmers are first to take the hit. Farmers faced the depression of the 1890s, the Great Depression, the financial crisis of the 1980s, and the 2008 recession. We have seen our St. Croix River valley farmers pick themselves up by their bootstraps time and again, but it is evident by the growing number of abandoned farms that even those with the thickest skin can sometimes not recover.

Whatever the reason our region's barns have disappeared, it is still imperative to remember and preserve their history. Each barn is an architectural timeline, telling a multifaceted story of both humanity and science, and it is just as artistic as it is practical in design. Understanding our agricultural past is imperative to preserving and growing our agricultural future.

# One
# GEOLOGICAL HISTORY

The geological and natural virtues of the St. Croix Valley are what attracted early pioneers to the region in the early to mid-1800s. With the St. Croix River and its tributaries, tall white pines, and rolling prairies, the valley was labeled an economic hub. While logging took the first firm grip on the region, farmers also utilized the vast resources to begin lives on the farmstead. (Courtesy of the Olesen-Bevens family.)

Aside from the St. Croix River, when the original settlers came upon this region they must have been struck with the same awe that any modern-day traveler experiences while hiking along the bluffs or driving along weaving country roads. A traveler may only see the aesthetic beauty of the region, but the original homesteaders probably took greater note of the rich soil and dense forests to build upon. (Courtesy of the Belisle family.)

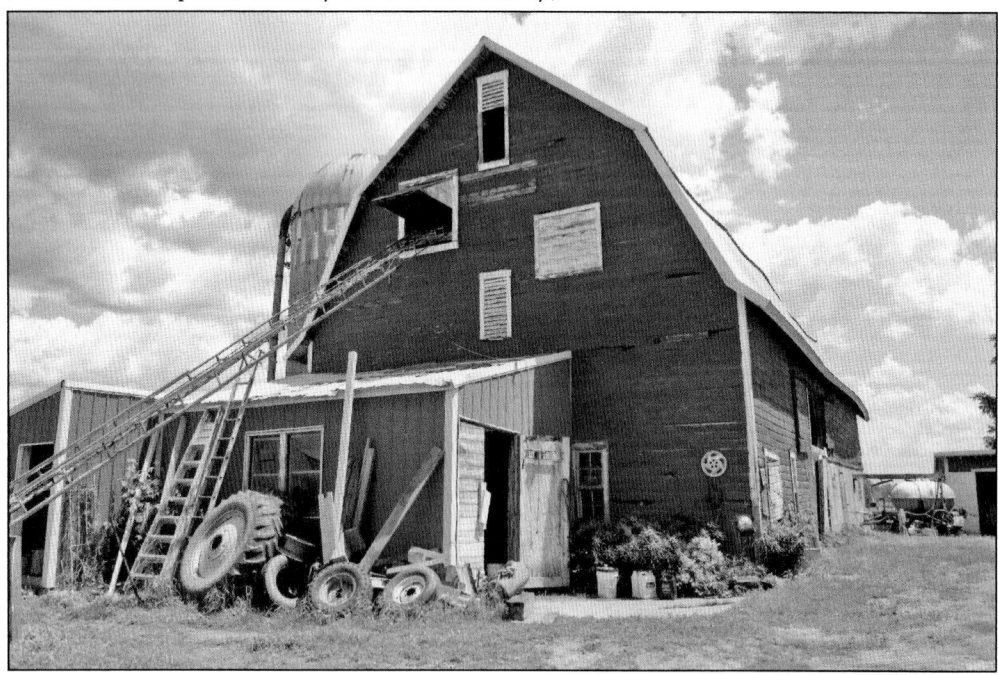

The historic St. Croix Valley has nearly 3,000 barns. Most are home to between 15 to 50 dairy cows, as the primary farming practice in the St. Croix Valley is dairy farming. The landscape is dotted with contented Holstein and Jersey dairy cattle, mulling about wide-open fields between milkings. (Courtesy of an Almelund, Minnesota, resident.)

Craslie Creamery in Baldwin, Wisconsin, used this region's white pine to build its business and its cows to make delicious butter. The open prairies are ideal for raising dairy cattle, and thanks to the Wisconsin Glacial Age, Wisconsin and Minnesota cattle and humans alike had access to 17,000 lakes to aid in early settlement and farmsteading. (Courtesy of the Baldwin Public Library.)

Traveling south, more limestone and shale are found near the river, which indicates a more recent geological formation. According to the *St. Croix Scenic Byway's* article "Geology and Glacial History," the St. Croix River is home to "100 large glacial potholes . . . in the two Interstate Parks. The only other place in the world with this kind of pothole display is in Switzerland." The geological history is truly of rare beauty. (Courtesy of the John Runk Collection, Stillwater Public Library.)

The landscape along the St. Croix Valley varies from steep bluffs to rolling hills. In St. Croix Falls and Osceola, Wisconsin, jagged boulders and steep cliffs jut out along the river, the result of a glacier that carved through the region. That glacier drove southward, tilling up the land and pulling rocks, sediment, and debris along with it. As the glacier continued south, driven by its own weight and gravity, it carved out the land and helped dig up the nutrients that were buried in the soil, bringing them to the surface. The glacier also uncovered dark basaltic rocks that now stand tall and robust along the river. Those rocks give way to thick forests, and eventually, flatter, more farmable land. (Both, courtesy of the John Runk Collection, Stillwater Public Library.)

The northern portion of the St. Croix River is home to Precambrian lava flow that has been dated to one billion years ago. The jutting rocks near Interstate Park are a blatant indication of this ancient occurrence. The narrow northern passages broaden as the river reaches Hudson, Wisconsin. The south end of the river is a result of more recent geological changes in the valley. (Courtesy of the John Runk Collection, Stillwater Public Library.)

Before settlement, the northern St. Croix Valley was primarily closed forestland, or extremely dense forests. The southern region was a combination of both prairie and closed forestland. The acres of dense forests were utilized to build farmhouses and outbuildings and, most relevantly, a farm's most important feature—its barns. (Courtesy of the Baldwin Public Library.)

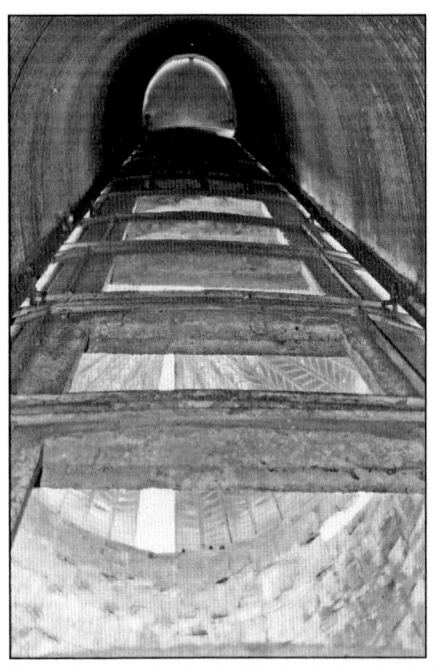

Barns functioned as storage for crops, machinery, livestock, and plowing horses, and served as the family's source of income. This photograph shows the inside of a silo, which was used for storing grain. When driving past any old farm in this region, anyone could see that the barn was far larger and more extravagant than the farmhouse. While the farm wife may have grumbled about this, it was a sign of good economic times in this region. (Courtesy of an Almelund resident.)

The climate also attracted many farmers to this region, such as Mary Lofgren, seen here. While Wisconsin is known for its cold winters, it balances out the frigid winter months with warm summers. The valley has on average a 145-day growing season that lasts from early May to October. Compared to other parts of the United States, this relatively short growing season still allows many forage plants to grow, such as alfalfa and legumes used for feeding livestock. (Courtesy of the Afton Historical Museum.)

This is a photograph of a barn in Somerset, Wisconsin, in 1933. This image perfectly encompasses what the *St. Croix Scenic Byway* describes as "flat, glacial outwash plains" in its article "Geology and Glacial History." Steep, jutting rocks are found along the river, and the land slowly flattens to the east and west. These flat plains are ideal for crop farming. (Courtesy of the Somerset Public Library.)

This is another example of how farmers in this region utilized the flat prairie land to suit their farming needs. Even if rural farmers were not near the St. Croix River, it is likely that they were near one of the river's tributaries or neighbor rivers: the Apple, Clam, Kinnickinnic, Namekagon, Trade and Willow Rivers in Wisconsin, and the Kettle, Snake, and Sunrise Rivers in Minnesota. (Courtesy of the Baldwin Public Library.)

The area surrounding the St. Croix River is not just flat plains. As seen here, heavily wooded forests are a major part of this area's scenery. Pineries became a major economic force in the St. Croix Valley, and nearly all of the large pines seen here were logged. Most of the trees in the St. Croix Valley today are approximately 100 years old—a legacy of the region's logging industry. (Courtesy of the Baldwin Public Library.)

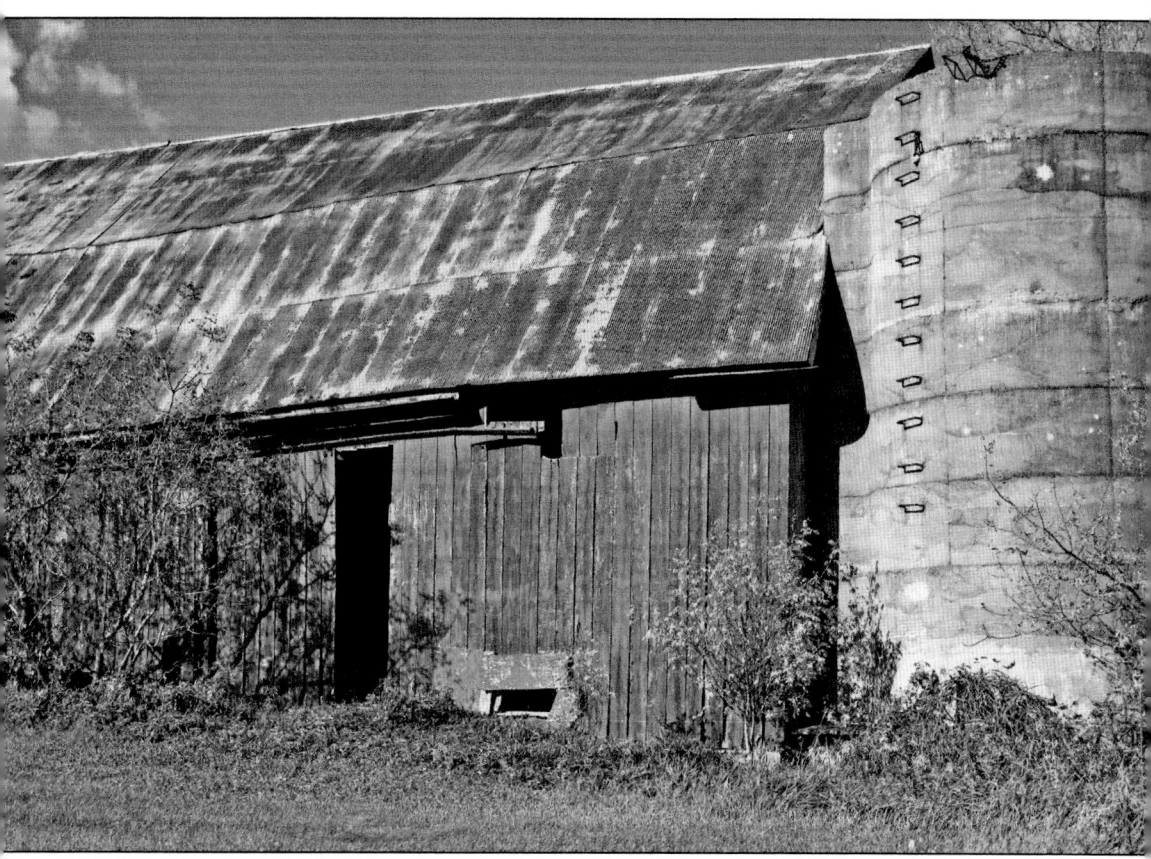

This beautiful region had all the necessary resources to start a successful dairy farm. Early farmers reaped the benefits of nutrient-dense soils, a warm growing season, a plentiful water supply, and a community of hardworking farmers and neighbors who were there to help through the best and worst times. (Courtesy of an Osceola resident.)

The railroad bridge in Hudson is visible in the background. Note that the riverbanks are not as steep and jagged along the southern portion of the river as they are on the northern portion. These younger rock formations consist mostly of limestone, sandstone, and shale. The southern portion of the river flows more slowly and widens into Lake St. Croix, which is just south of this picture. Historically, this location was ideal for loggers' boom sites. At present, the area is better known for leisure boating and its beaches. (Courtesy of the Hudson Public Library.)

# Two
# EARLY PIONEERS

Early pioneers were met with a variety of obstacles. Unforgiving weather, disease, seclusion, Native American relationships, and many more challenges faced early settlers. Despite these difficulties, thriving communities were born. (Courtesy of the Olesen-Bevens family.)

Pictured are three young boys from Baldwin. In the early stages of settlement, many families were afraid to settle in this region due to rumors or misrepresentations of Native Americans and their culture. When the first European settlers arrived in the St. Croix Valley, they realized the importance of building positive relationships with the Native Americans. (Courtesy of the Baldwin Public Library.)

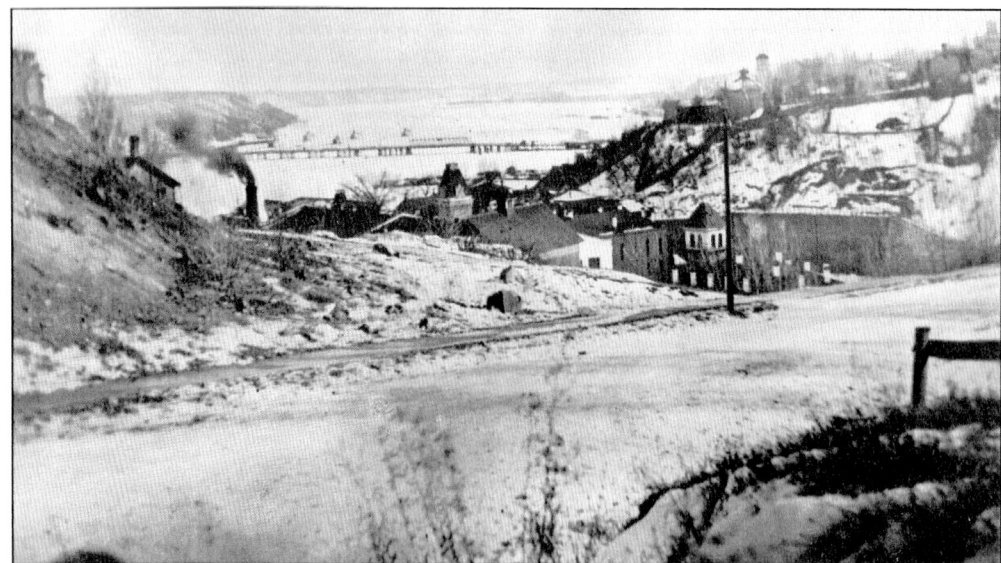
While many pioneers had been fearful of the Native Americans, conflict with them was minimal. The Ojibwe and Dakota occupied the region, with the Ojibwe occupying land east of the St. Croix River and the Dakota occupying the west side. These tribes both seemed to have working relationships with Europeans; however, the two were enemies with each other. (Courtesy of the John Runk Collection, Stillwater Public Library.)

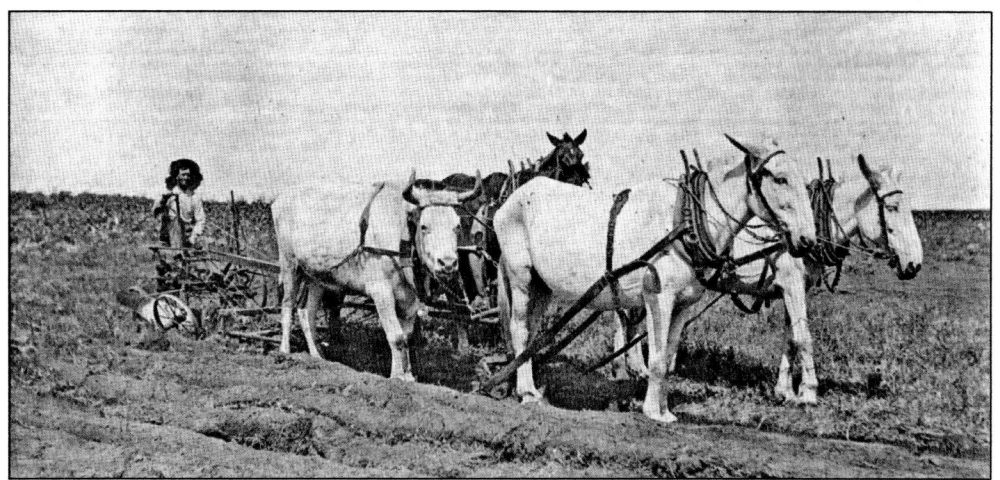

Here is an early farmer plowing his field. Many farmers had civil relationships with the Native Americans. The majority of the time, it seemed as though the two groups were a curiosity to one another. Two cultures from nearly opposite sides of the world had come to occupy one region, so naturally, there were misunderstandings—some of a comical nature and others more grave. (Courtesy of the Baldwin Public Library.)

An example of the Dakota and Ojibwe's warring relationship was the massacre on the Apple River in 1850. The Dakota led a surprise attack on the Ojibwe in what is present-day Polk County. According to author Ken Marten, the Dakota war party then departed for Stillwater, Minnesota, and, still dressed in their war paint, commenced a scalp dance on Broadway Street. Understandably, the residents of Stillwater were frightened. This act may have seemed barbarous to the European settlers, but scalping and war dances were Native American traditions. (Courtesy of the John Runk Collection, Stillwater Public Library.)

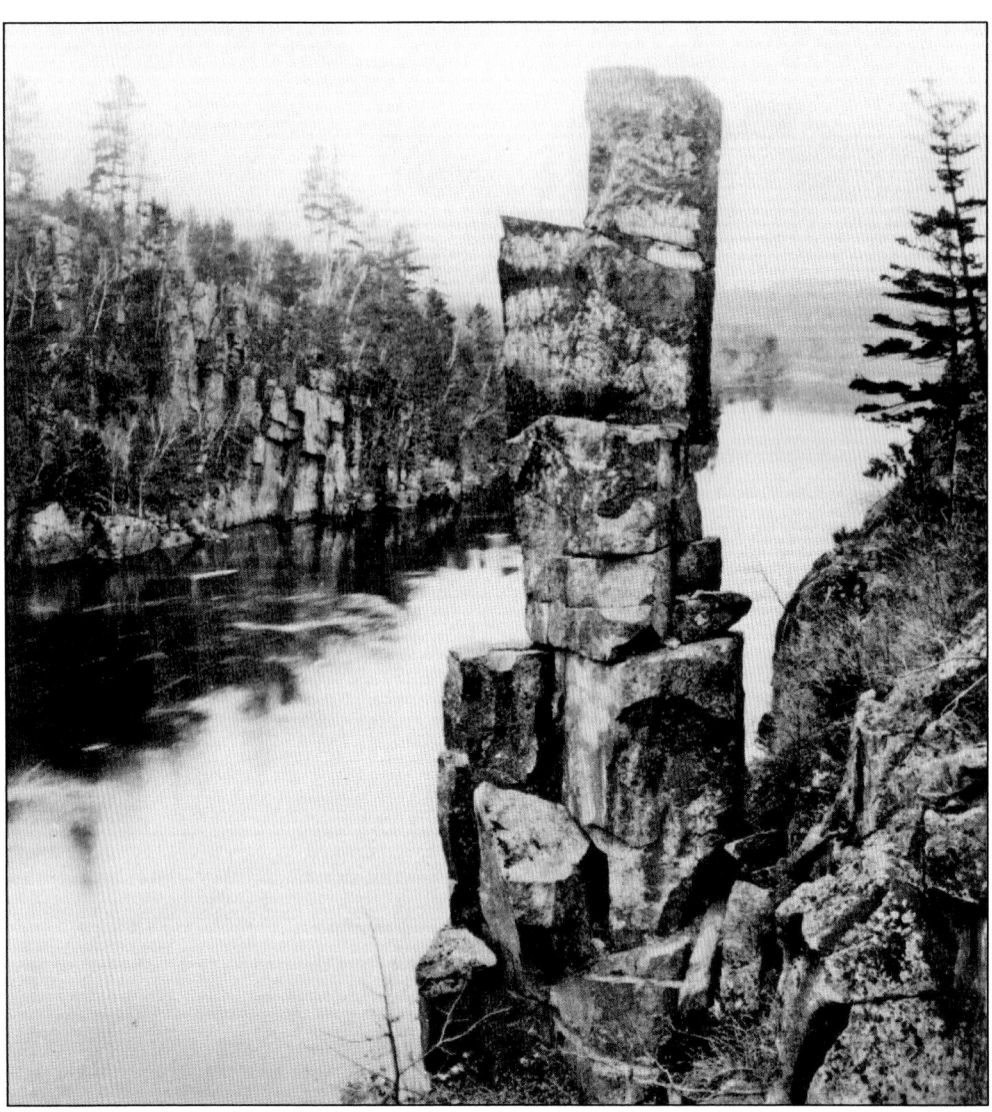
There are many tales and much speculation as to how St. Croix County received its name. A theory shared by the University of Wisconsin–River Falls speculates that the county received its name from Father Hennepin, a native of Ath, Belgium. Hennepin had traveled to Quebec to begin his life as a Franciscan missionary. Through his missionary work, he traveled south in the spring of 1680 to explore the Mississippi River. (Courtesy of the John Runk Collection, Stillwater Public Library.)

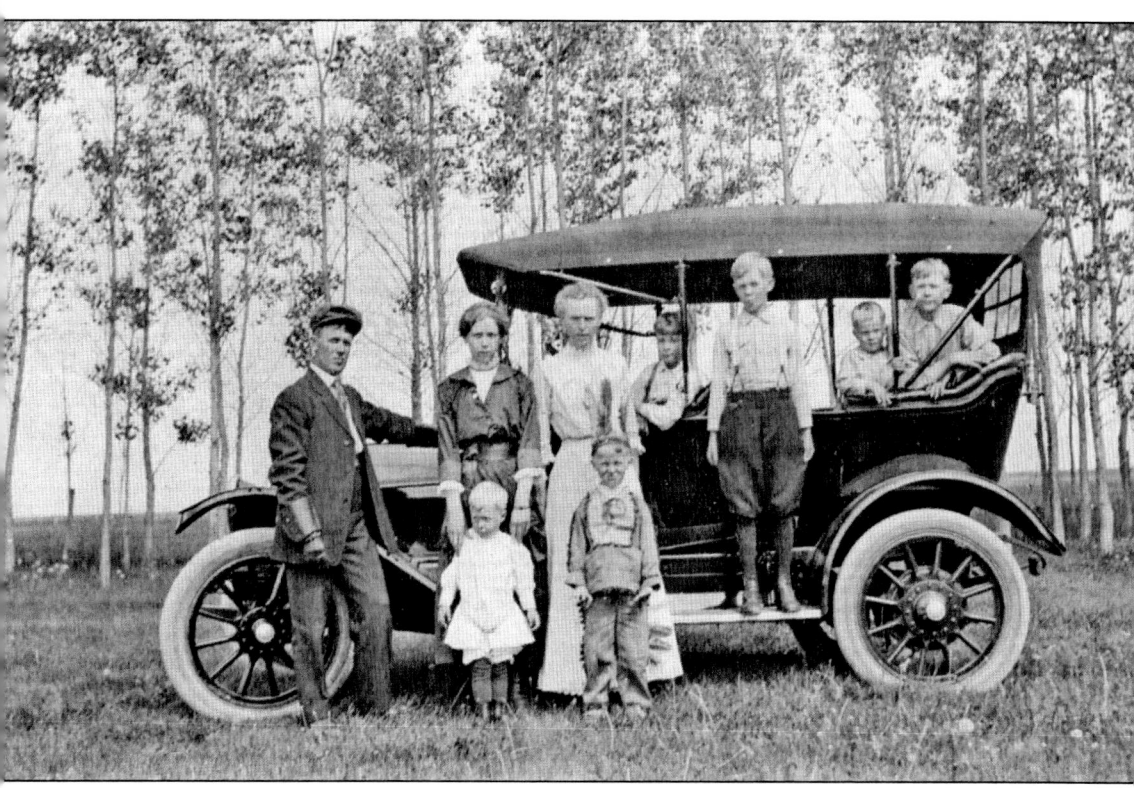

It did not take long before Hennepin was taken captive by the Dakota. After spending only a few months in captivity, Hennepin was released. He took up writing of his travels in the New World, and in his book, *A Description of Louisiana, newly discovered to the South-West of New France*, he wove far-fetched tales. The landscape became much more dangerous, the waters far mightier, and the Native Americans far more barbarous—and of course, his blithe escapes much more fantastic. After publishing two more well-read books of the kind, it did not take long for word to spread that Father Hennepin tended to stretch the truth. Still, Hennepin was one of the first white visitors to the area and aptly named the region Saint Croix, meaning "Holy Cross." Here, a family poses for a picture, and the boy in front is wearing a native headdress. Despite Hennepin's stories, the reality was that pioneers and Native Americans tended to have peaceful relationships. (Courtesy of the Baldwin Public Library.)

Helen Hilton summed up Wisconsin winters perfectly in her poem "Winter." "Cold, cruel winds, drifting snow / on crisp winter nights, the sound / of wolves / baying at the bright full moon / while dark shadows lurk / beneath the barren boughs below / Inside, warmth and comfort / books, games and soft laughter / bright flames showing thru / the isinglass of the big stove / leaving a golden glow / After an all night storm / no sound / only the pristine whiteness / under the morning sun / no tracks or sign / of rabbit, squirrel or fox / only silence, loneliness and awe / as we gaze thru windows / at serene beauty / left by wind and drifting snow. (Above, courtesy of the John Runk Collection, Stillwater Public Library; below, courtesy of the Hudson Public Library.)

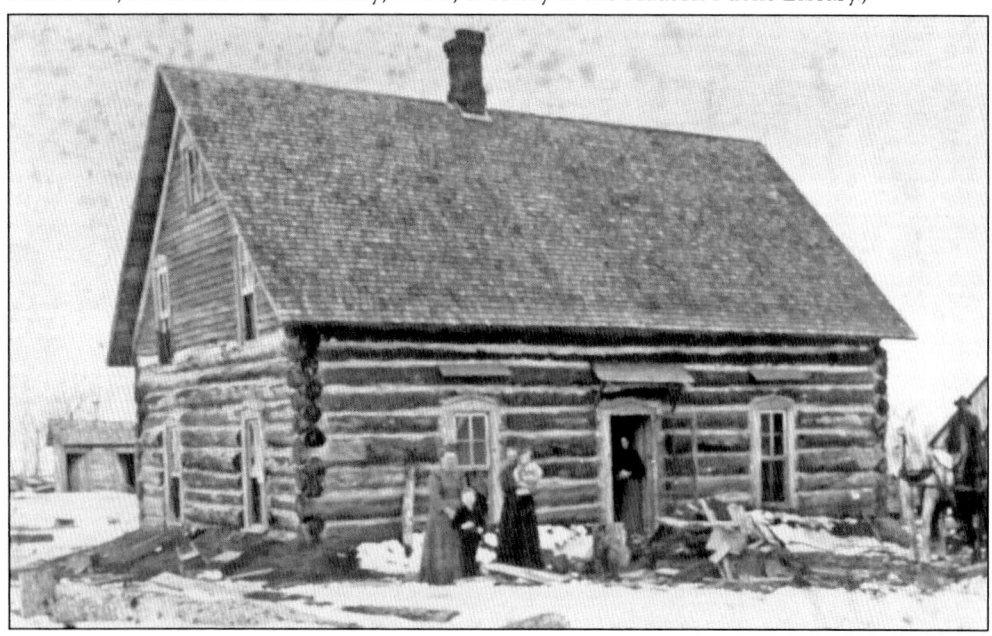

In an article titled "The Immigrants" in the *Ames Evening Times* on February 27, 1919, the author wrote of a family that had emigrated from Ireland: "When they went on to Hudson, Wisconsin, some of the snow drifts were 20 feet deep, quite a change from the green grass fields of Ireland where if any snow falls it is all melted in an hour." (Courtesy of an Almelund resident.)

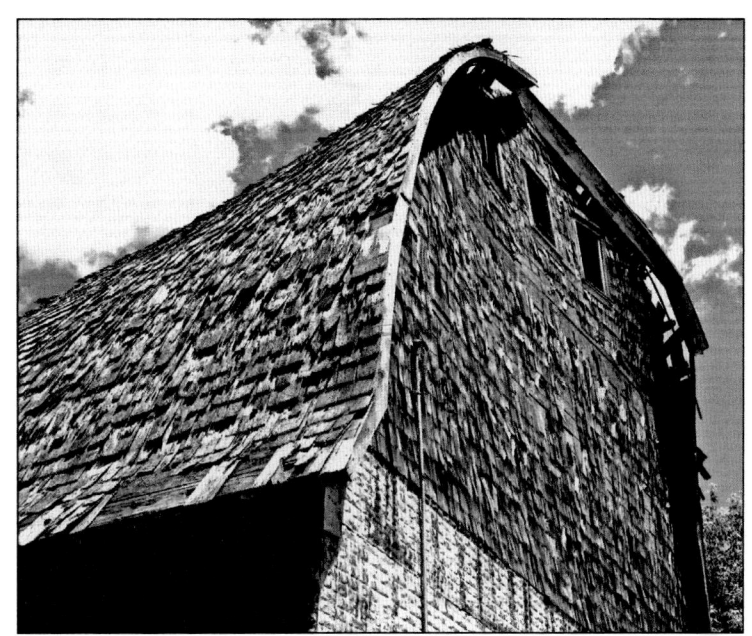

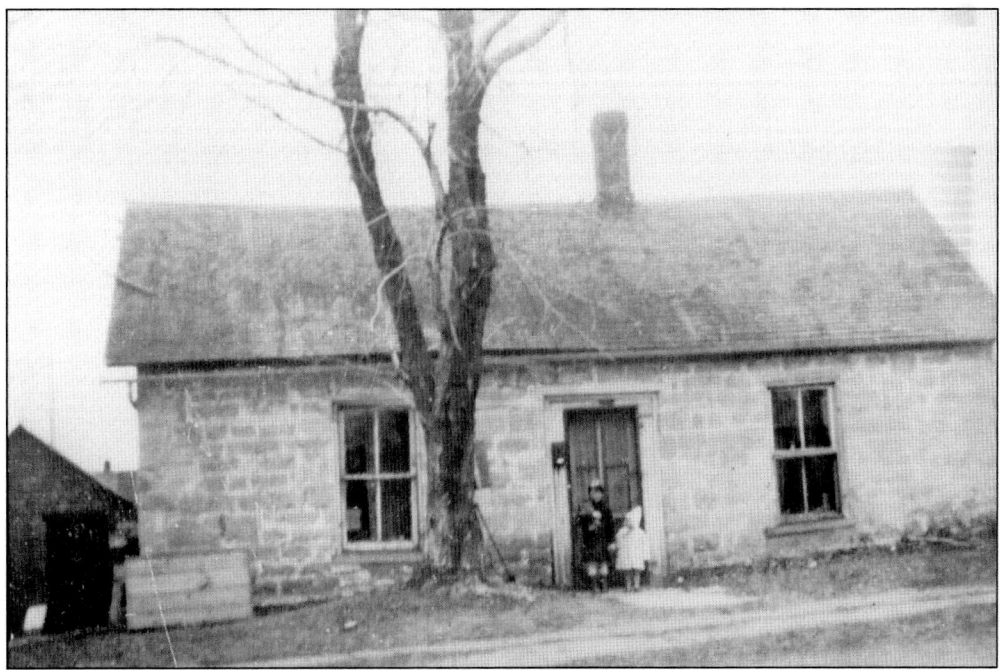

This home is representative of many of the early pioneer's homes. Lumber, agriculture, trade, and whiskey all enticed the early pioneers to make the difficult journey to this region. The majority of the first settlers were transplants from the East. The promise of cheap but bountiful land, now purchased at less risk because of the preliminary land surveys, drew in people interested in mining, logging, and agriculture. (Courtesy of the Boucher family.)

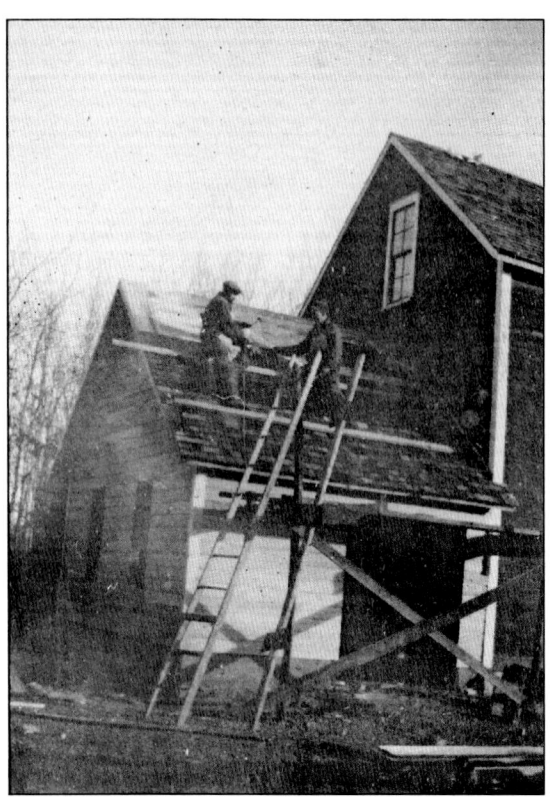

Seen here are two men working on the roof of what is presumably the milk house. The area's early communities were a rich blend of cultures. Between 1835 and 1885, more people with German heritage made up the St. Croix Valley's population than any other cultural background. (Courtesy of a Hudson resident.)

In close second were those of Norwegian background, and by 1850, two-thirds of all Norwegians in the United States resided in Wisconsin. However, while Germans and Norwegians largely called Wisconsin home, pre-1900 Wisconsin also included Belgians, Danes, Czechs, English, French, Fins, Italians, Icelanders, Swiss, and far more. (Courtesy of the John Runk Collection, Stillwater Public Library.)

The broad diversity of Wisconsin's settlers is largely why many barns in this region are so different. Each immigrant brought with them not only the barn styles of their homelands, but also their own individual style and farming needs. Every settler's unique architecture had to also be adapted to this region's environment. An example of a successful adaptation is the German dairy farm in St. Croix Valley by the German settlement in Hudson. The German barn style would be very similar to the one shown here. The land was originally founded by Nicholas and Hely Schwalen, who were immigrants from Prussia in the 1850s. (Courtesy of an Almelund family.)

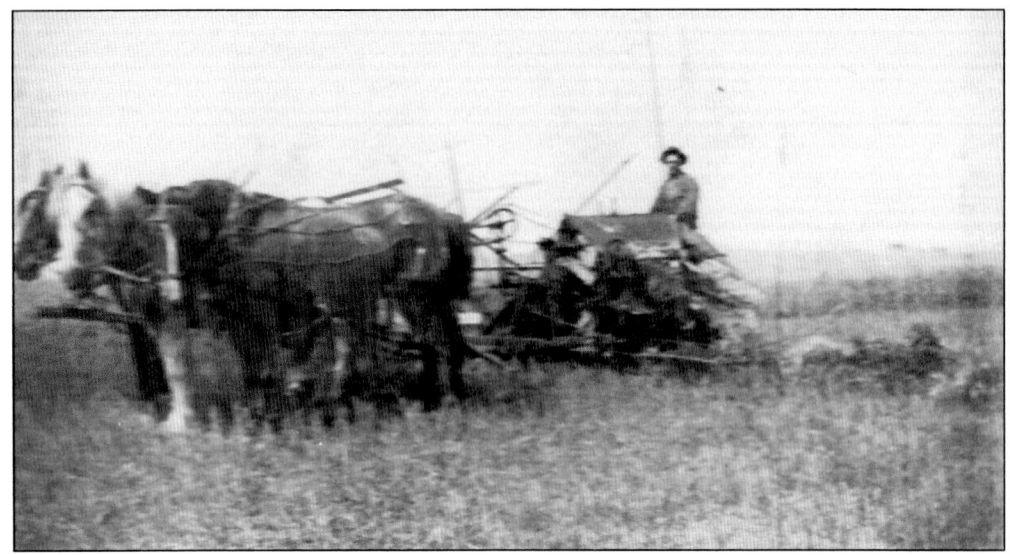

The Schwalens were among the first farmers in the St. Croix Valley and were soon joined by over 10 families to form a large settlement. Their descendants and other volunteers are still active in sharing and preserving their family's heritage. This holds true for other farming families who are proud to share their heritage and family stories with anyone interested. (Courtesy of the Afton Historical Museum.)

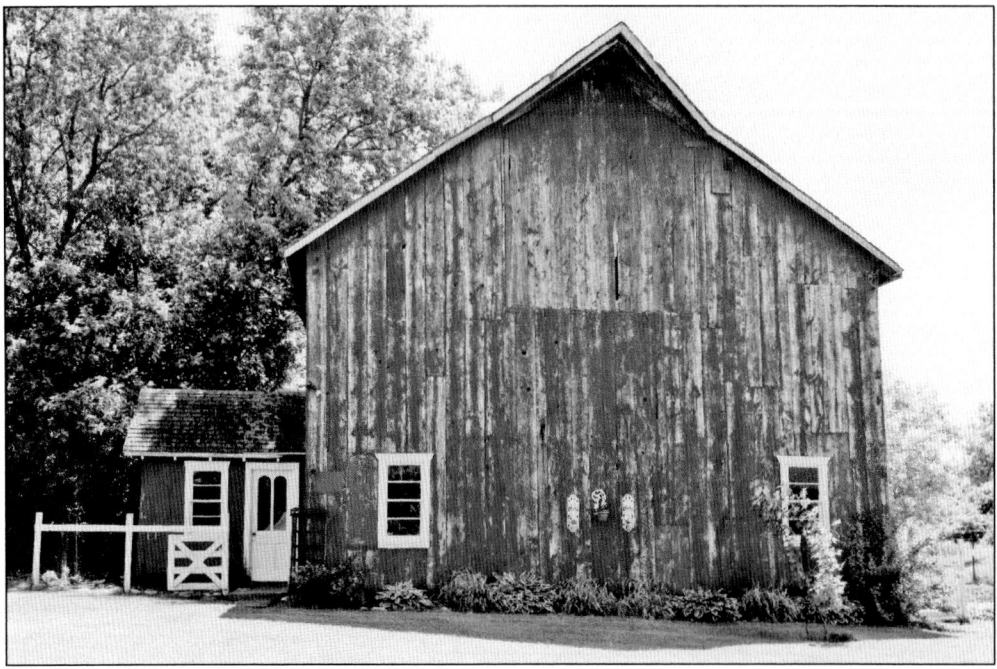

Chisago County has a beautiful blend of small-town charm and rustic farmland. Similar to other counties in this region, Chisago's beginnings were in fur trading and eventually logging. As land was cleared of its enormous white pines, farmers began to arrive with high hopes that the logged land would yield successful crops. When settlers began arriving to the area in 1838, the logging industry had a turbulent start, but the farmers benefited from purchasing the already cleared land. (Courtesy of an Almelund resident.)

The northwestern region of the valley was inhabited primarily by people of Swedish descent, and the area's population had grown to 10,000 before 1900. Many of the Swedes had opted to live in Center City, Minnesota, where the courthouse was established. In 1851, the county was officially established by the territorial legislature of Minnesota. Soon after, in 1852, the first government road was built. This road traveled from Fort Snelling in Missouri to Superior, Wisconsin. (Courtesy of a Shafer, Minnesota, resident.)

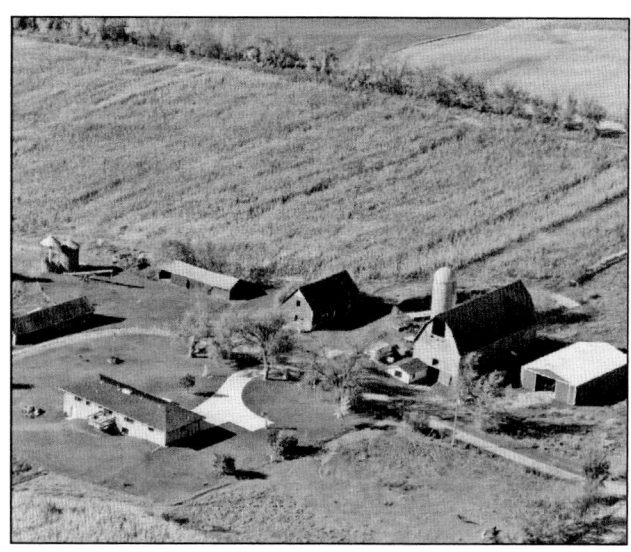

Shown here is Main Street in Hudson. The city has since been built and rebuilt but still retains many of its historic brick buildings, such as these. This city has not always been named Hudson. It was originally named Willow River. As boundaries changed, the name became Buena Vista. There were continuous debates throughout the community as to which name was most fitting for this beautiful, bustling town. Finally, in November 1852, resident Alfred Day suggested the name "Hudson" after its similarities to the Hudson River in New York. Since then, this community tucked beside the St. Croix River has been named Hudson. (Courtesy of the Hudson Public Library.)

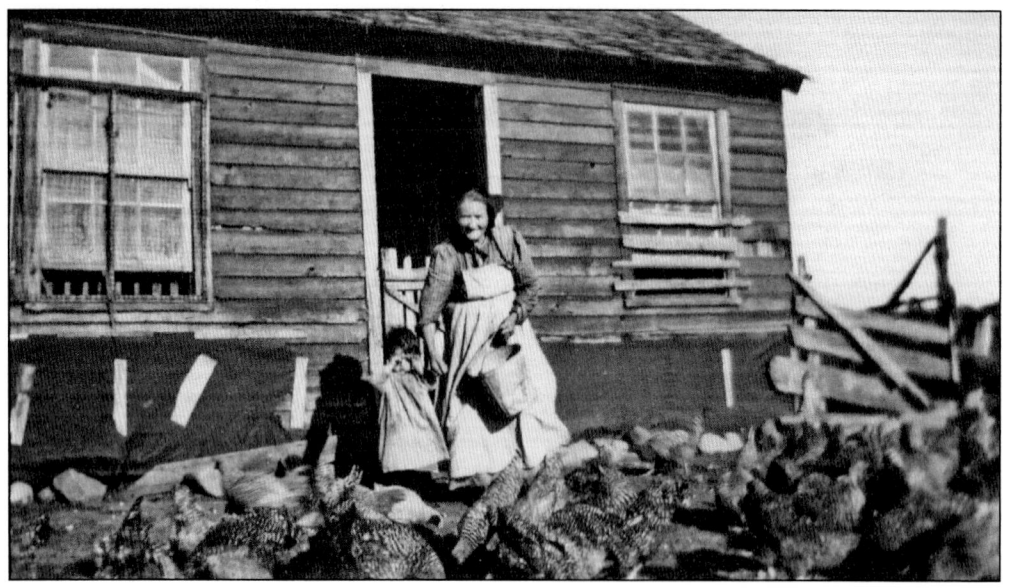

The above photograph was taken in 1857 of "Grandma" Catherine Walsh Lewis feeding the chickens. The building has been lovingly called the "Honeymoon Shack," which was the building that Daniel Lewis originally built when he arrived in 1854. Mary McKay, a descendant of Daniel Lewis, described it as "a one-room shack with kind of rifle windows . . . no insulation, no glass." It is speculated that the shack was later turned into a chicken coop after the family built their permanent home. The Lewis farm was primarily reserved for dairy farming, but it is also believed that Daniel grew wheat. He certainly was not alone in wheat farming—by the 1850s, wheat production and sales trumped even the lumber industry. The photograph below gives a glimpse of what the Lewis-McKay homestead became in future years. (Both, courtesy of the Lewis-McKay family.)

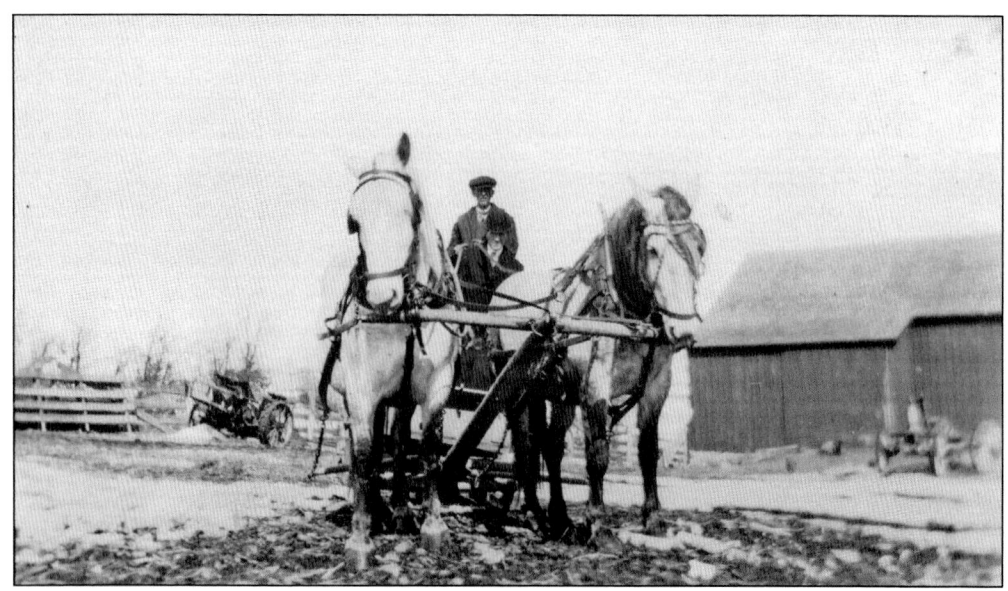

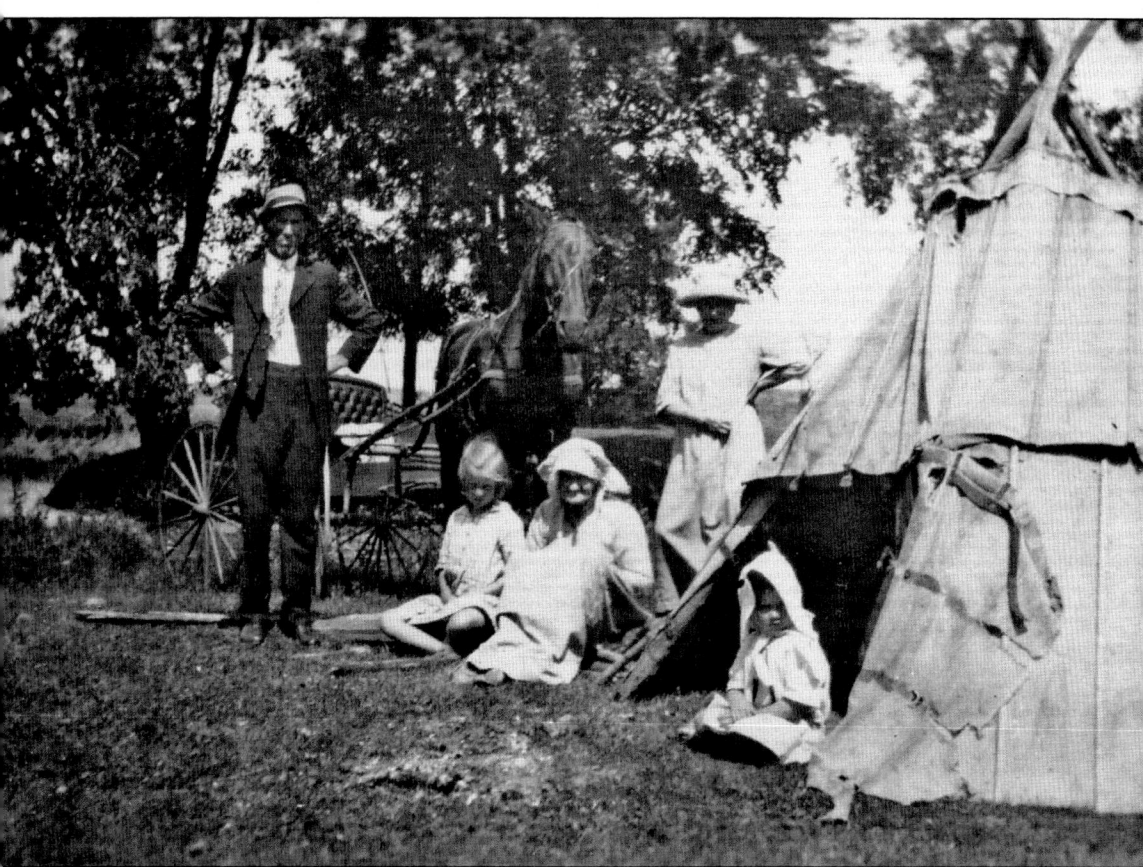

The Lewis-McKay family is pictured outside their tepee, which was set up by the creek in the summer months to keep cool. Electricity and running water were not introduced to the McKay-Lewis Farm until 1982. Mary's mother remembered staking a goat around the house to keep the grass down. Daniel Lewis had a fascinating life. According to Mary, Daniel "died when my grandmother was twelve . . . he had a goiter which was a thyroid issue which is almost unheard of nowadays because they add iodine to the salt." During the interview Mary stated, "He had [the] operation on this very table. He did not survive the operation, though." (Courtesy of the Lewis-McKay family.)

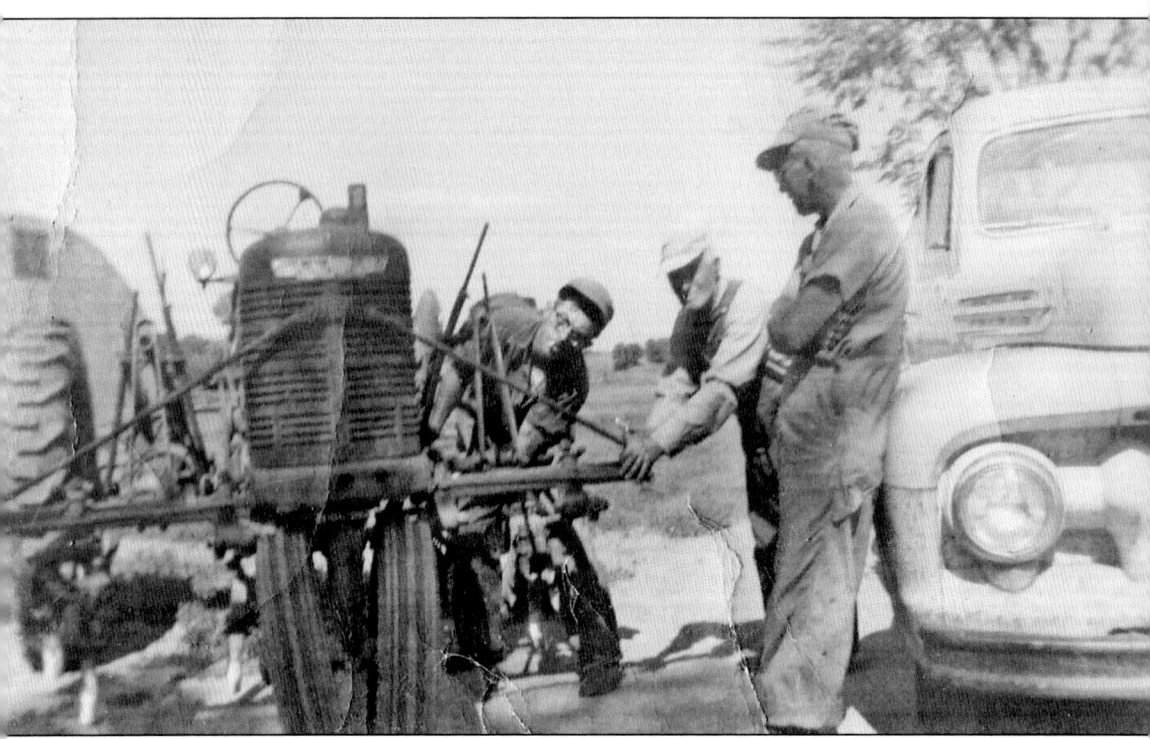

From left to right, Duane Boucher, Norval Boucher, and Harold Turner are pictured working on a tractor. The Village View Dairy Farm in East Farmington was homesteaded by Louis Napoleon and Amelia Boucher in 1877. The farm was passed down to Norval and Edith Boucher in 1925. At that time, milking was done by hand and the milk was stored in 60-pound buckets. Milk was picked up every other day, and in order to keep it cool, it had to be stored in a trough that was circulated by a windmill. When it was picked up, the milk would be taken to local cheese factories, such as Bass Lake Cheese and F&A Dairy, and more well-known milk distributors such as Land 'O' Lakes and Kemps. (Courtesy of the Boucher family.)

This c. 1880 photograph shows John and Magdalina Getschel. They had settled in Wisconsin after emigrating from Germany and purchased their farm in Osceola in 1887. The barn and farmhouse they built are still in use today. Milk transportation was done daily. Before bulk tanks, their milk was stored in cans weighing approximately 85 pounds each. (Courtesy of the Getschel family.)

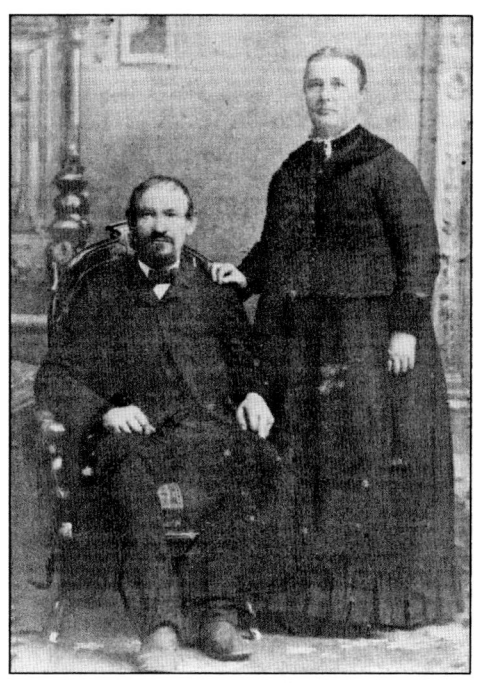

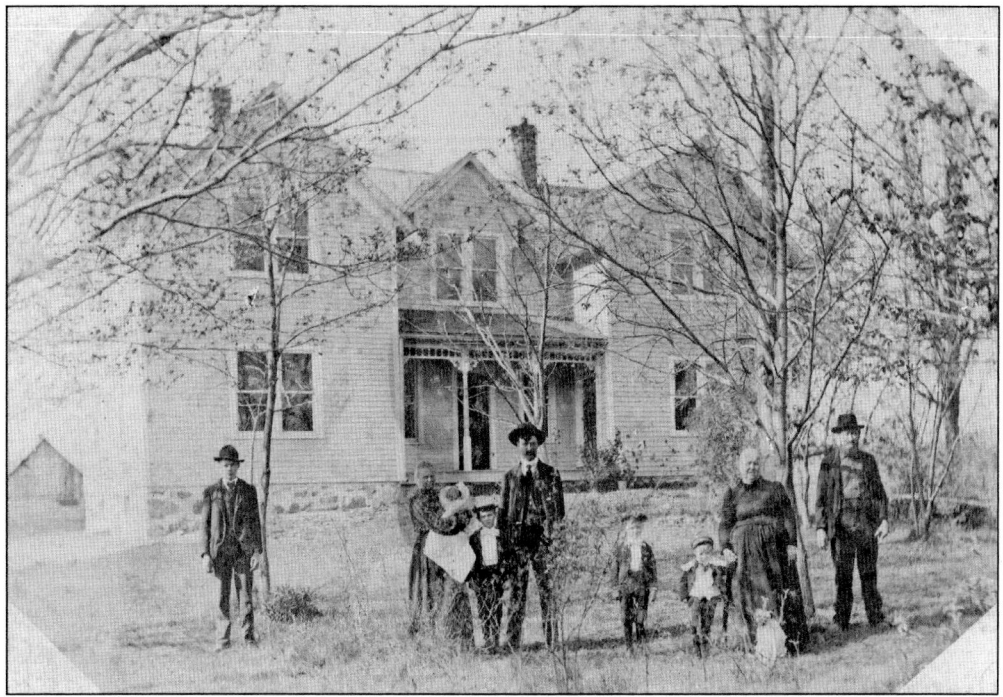

Homesteaders of the Getschel farm are pictured around 1880. At far right are Peter and Magdalina; they had traveled from Germany in hopes of creating a better life in the United States. The farmhouse pictured is still in use today. Originally, their dairy farm was 120 acres. Before the Rural Electrification Act and automatic barn cleaners, John Getschel said everything was done by hand, including the grueling work of shoveling manure by hand from the barn gutters. (Courtesy of the Getschel family.)

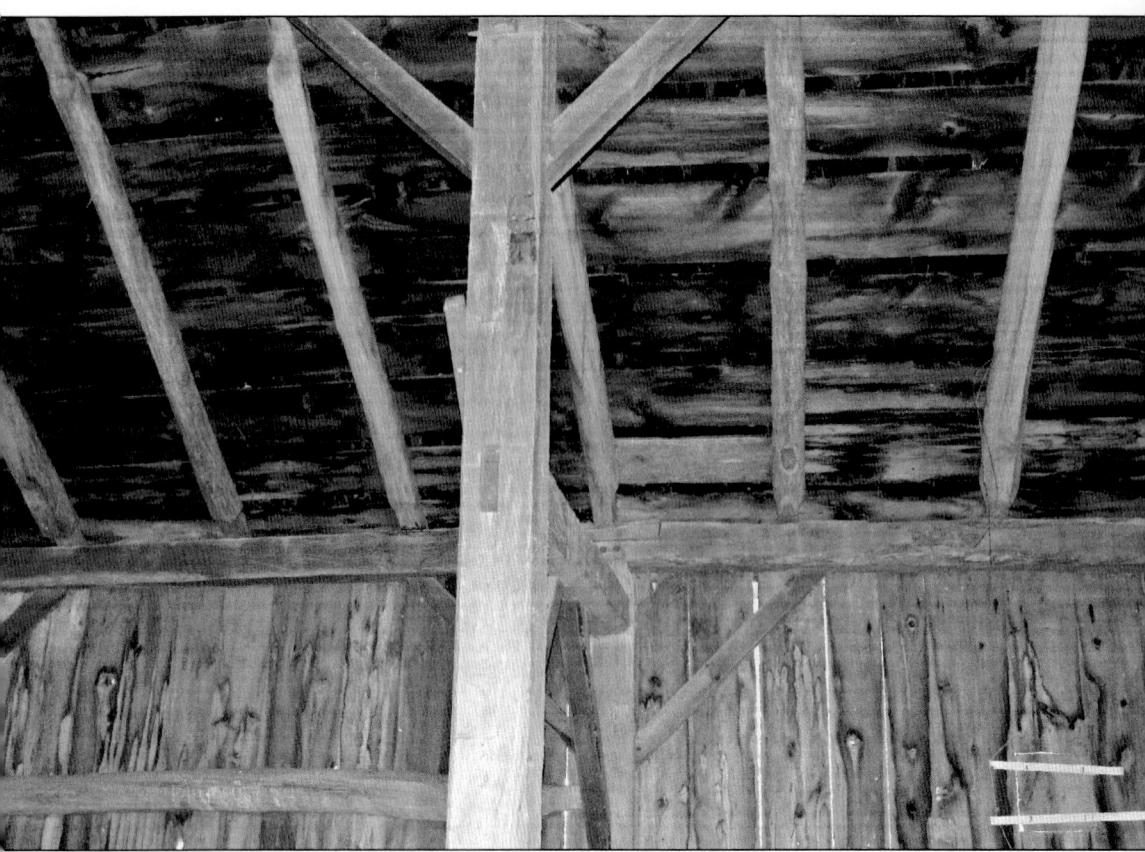

Joseph Haskell was a Minnesota pioneer whose efforts are worth mentioning. Being a pioneer in Minnesota was far from a walk in the park. The first pioneers lived in shacks and fought off the gruesome Minnesota winters, and it was even rumored that Haskell cooked his meals on the same metal shovel he used to work in the fields all day. Haskell's first crops were corn and wheat, which were planted in 1840. The grand title of "First Minnesotan Farmer" was given to Haskell because, in 1840, he was the first farmer to sell his produce. Haskell, however, was not the only farmer in the area to have a fascinating story. Pictured here is an example of the post-and-beam building style that early farmers such as Haskell would have used to construct their barns. (Courtesy of an Almelund resident.)

Joseph Shaw traveled to Minnesota in 1857. Shaw and his wife, Jane Ann Mitchell, were natives of Broome County, New York. Shaw arrived in Lakeland, Minnesota, in 1857 with, shockingly, only a dime left in his pocket. After arriving in Lakeland, he immediately sought work in Afton and began doing odd jobs in the hope of being able to save enough money to purchase land. In the meantime, he wrote home to his wife as often as he could. (Courtesy of the Afton Historical Museum.)

The following is an excerpt from Joseph Shaw's letter dated May 16, 1857: "Last week I went to work on the farm plowing and harrowing. Got a very good idea of prairie farming he [landowner] has sowed 50 acres and is going to sow and plant 30 acres more. He has 15 acres of spring wheat sowed. He has about 100 bushels of wheat on hand. Looks about as plump as York State winter wheat, has 200 bush potatoes. I ate of them the best I've ate this year. Had corn and other grain in abundance, I fared better there than at any other place since I left Steuben and that's saying a good deal." (Courtesy of the Afton Historical Museum.)

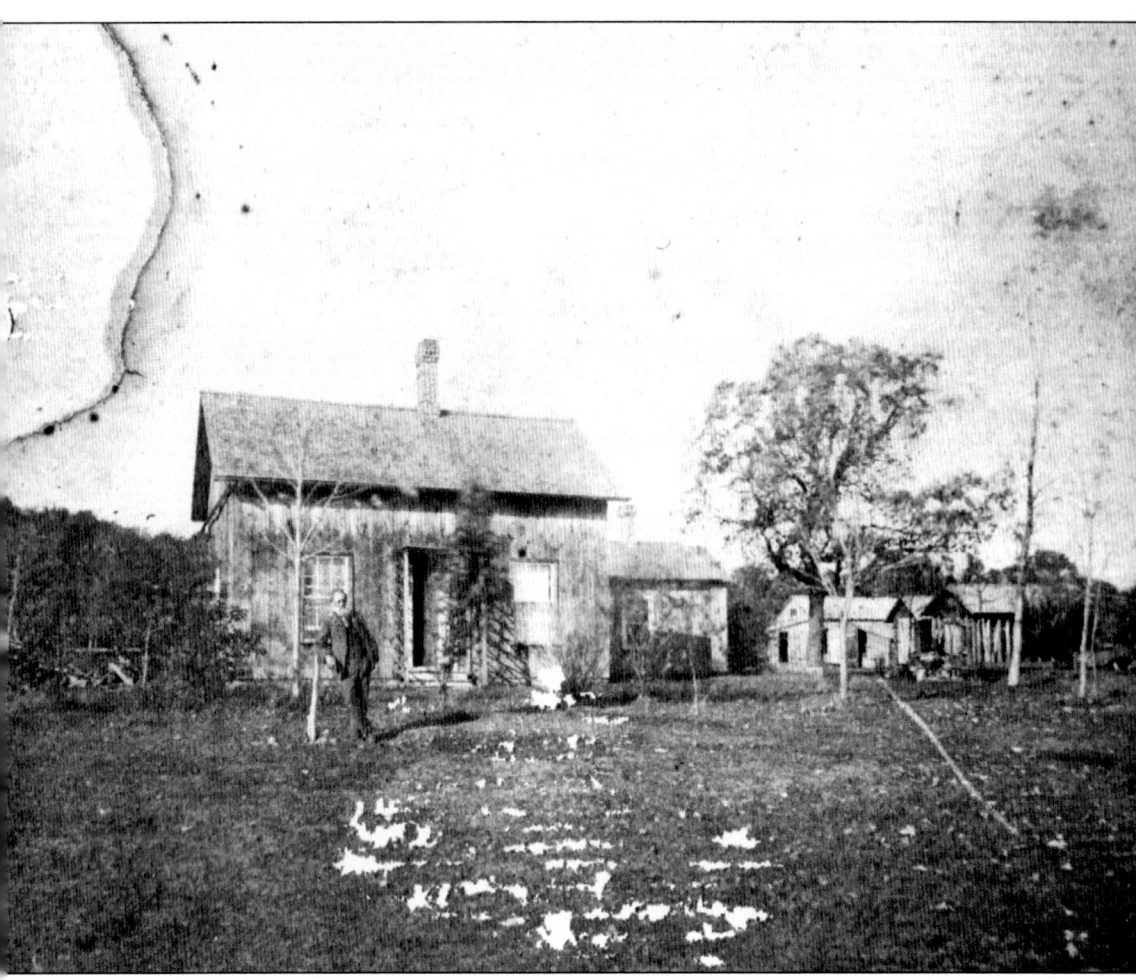

It was evident that Jane was anxious, and Shaw tried to conceal many of the struggles he experienced. In his letter of May 25, 1857, the truth finally emerged: "Well, I conclude your nerves are sufficiently strong enough now to bear the truth, so I will inform you that I arrived in this territory two weeks ago last Sunday with only 10 cents in my pocket. That was not of much consequence for every one of my pockets had a hole in it." At least in times of hardship, Shaw still had a good sense of humor. Eventually, he purchased the land pictured here, brought his family to Afton, and began farming. His hard work and dedication certainly paid off. (Courtesy of the Afton Historical Museum.)

The first white settlers were primarily French fur traders, and in 1793, an official trading post was created in St. Croix County. It has been said that Laurient Barth, Jacques Portier, and Charles Reaume chose this location because of its relative safety. The trading post was a successful endeavor for many years until the population and economic demands changed. In 1837, the Sioux and Chippewa signed a treaty that opened a portion of St. Croix County up for settlement, and official development began. There should be an emphasis on "official" development. Prior to 1837, St. Croix County was home to many squatters who logged and farmed the land illegally. Around 1834, pioneers were already utilizing the land for farming. The St. Louis Lumber Company brought in economic growth that led to a population increase and the building of towns such as Stillwater and St. Paul, which were then part of St. Croix County. (Above, courtesy of the Afton Historical Museum; below, courtesy of a Hudson resident.)

Early farmsteader Tom Cooney did not have to worry about his corn being "knee high by the Fourth of July." Here, Cooney proudly measures his cornstalks on his farm in Afton. Joseph Shaw summed up what many early farmers were thinking about the St. Croix Valley: "I think this is a fine land as I ever saw. They say garden vegetables grow very large and very quick after they once started the gardens. I've seen made look as black as those of NY state that have been manured for years." (Courtesy of the Afton Historical Museum.)

Patrons of the Somerset Hotel and Saloon are photographed outside the building in 1908. The logging and wheat boom aided these small towns' local economies. Small grocery stores, saloons, and other businesses began to take root around the turn of the 20th century. (Courtesy of the Somerset Public Library.)

Each small town seems to have at least one memorable character whose stories continue to be passed down even today. Pictured here is John Till, the Somerset "Plaster Doctor," who supposedly cured patients from around the country with his novelty plaster cure. Till's name is referenced in newspapers and journals by local community members who claim their ailments "from bunions to cancer" were cured by Till's top-secret concoction. (Courtesy of the Somerset Public Library.)

Patients wait outside John Till's home on New Year's Eve in 1911. While many in the area chose to make their name in logging, private practices, and agriculture, John Till was becoming known around Somerset as the "Barefoot Doctor." (Courtesy of the Somerset Public Library.)

Early pioneers of the St. Croix Valley are pictured outside their log home. Pioneers of Hudson often had many fascinating stories to tell. In her 1977 memoir *Winter Tales*, Helen Hilton mentions the extra work that winter brought to the farm. Just to get outside, her mother would dress her in "woolen underwear, a knit woolen petticoat and woolen dress, long woolen stockings and over these, overshoes and leggings topped by a heavy coat or jacket and last but not least, a stocking cap and a long woolen scarf wrapped around my neck." (Courtesy of the Somerset Public Library.)

Early efforts to grow and establish businesses, such as this feed mill in Stillwater, and the region's numerous farmsteads, helped shape today's communities. From early pioneers like Joseph Shaw to quirky characters like John Till, each affected the growth and development of the prosperous communities people live in today. (Courtesy of the John Runk Collection, Stillwater Public Library.)

# *Three*
# GOVERNMENT INFLUENCE

As Europeans pushed west in their quest for discovery, it did not take long for them to discover and spread the word about the abundance of resources Wisconsin and Minnesota had to offer. The first European credited with discovering Wisconsin was French explorer Jean Nicolet, who had arrived in what is now Green Bay in 1634. (Courtesy of an Almelund resident.)

In the beginning, the primary focus was trading furs and other goods with the Native Americans. However, as more and more explorers returned home with stories of great rivers, abundant game, and swaths of "unused" land, the US government began to take notice. (Courtesy of an Almelund resident.)

This photograph was taken on the Nielson Farm in Milltown Township. Throughout its history, the US government was active in helping early settlers acquire land. The first congressional act that the government passed aided those who fought in the Continental Army during the Revolutionary War to acquire land. (Courtesy of the Osceola Historical Society.)

In 1776, the government would give 100 to 500 acres of "free" land to those who fought. It continued in many shapes and forms from there. The Land Ordinance law in 1785 urged the survey of land northwest of Ohio. After the Native Americans ceded their land between 1832 and 1833, government surveyors began to examine the features Wisconsin had to offer. (Courtesy of the Hudson Public Library.)

Surveyors would mark each half-mile and state the kind of vegetation, soil, and other noteworthy details in order to give an accurate description of the land for a future settler. The Preemption Act of 1841 addressed a problem that many of the Western states were facing: squatters. Un-surveyed land throughout the Midwest was "claimed" before the government had a chance to auction it off. (Courtesy of the Baldwin Public Library.)

A growing number of squatters were using un-surveyed, free land for farming and logging in the St. Croix Valley. The Preemption Act was a solution to the problem of freeloading squatters. After 14 months of living on the land, squatters could purchase up to 160 acres for as little as $1.25 per acre before it was offered for public sale. This act helped legitimize the squatters into official settlers. (Courtesy of the John Runk Collection, Stillwater Public Library.)

Towns such as Somerset, pictured here, began to grow as the Homestead Act blossomed. There was a rush to file for land claims, and homesteaders could file for up to 160 acres in most areas. The Homestead Act continued to evolve and promote homesteading for agricultural purposes. Some provisions were passed to aid farmers in the plains and desert regions and to promote westward expansion into Oregon and Washington. (Courtesy of the Somerset Public Library.)

The Preemption Act eventually fell out of use with the advent of the Homestead Act, which was passed in 1862. The Homestead Act continually changed and updated throughout the years, and there are still rare cases of it being used on the United States' last frontier, Alaska. Galusha A. Grow strongly advocated for the passing of the Homestead Act, which had been in limbo and consistently turned down and vetoed for nearly 20 years before it was finally passed in 1862. According to the Bureau of Land Management, Grow was considered the "Father of the Homestead Law." His work came to fruition while he acted as speaker of the House of Representatives when Abraham Lincoln finally signed the act. (Above, courtesy of the Getschel family; below, courtesy of the John Runk Collection, Stillwater Public Library.)

In 1913, the Homestead Act had reached its peak at 11 million acres claimed. Barns built during this period, much like the one seen here, were a sign of successful farmsteading because of the Homestead Act. The act continued to aid homesteaders until 1976, when the passage of the Federal Land Policy and Management Act repealed all homestead laws in the continental United States, marking the end of an era. (Courtesy of a Dresser, Wisconsin, resident.)

Surveyors created the "Point of All Beginnings" in Wisconsin in order to start blocking off land for examination. Two lines were drawn to create this point. One line is now the Illinois border, and a northward line starts at the mouth of the Illinois River. Every township and settlement started from this point. Early settlers were required to improve the land once they purchased it; a barn, such as this one, would have been a notable improvement. (Courtesy of an Almelund resident.)

The Soil Conservation and Domestic Allotment Act of 1935 affected farmers throughout the nation, including this family from the Baldwin area. This was another act aimed at assisting farmers through the Great Depression. While this act most greatly influenced farmers on the plains, it also promoted soil conservation for farmers in the St. Croix Valley who were stuck on growing the soil-depleting wheat. (Courtesy of the Baldwin Public Library.)

This photograph was taken on the Lewis-McKay family farm around 1930. The need to acquire updated farming equipment during a time of falling produce prices put many farmers in a difficult financial situation. When the stock market crashed in 1929, Franklin D. Roosevelt created the New Deal, a series of initiatives aimed at repairing the faltering US economy. One of these initiatives was the Agricultural Adjustment Administration (AAA), which identified seven key commodities: wheat, cotton, corn, rice, hogs, milk, and tobacco. The AAA then paid farmers to produce less of these products in order to create an artificial scarcity. This plan did not go over well with Americans who were suffering the losses of the Great Depression. Farmers were throwing out or not plowing millions of acres of already planted crops; it was an incredible waste during a time of great need. What it perhaps lacked in ethics, it gained in economic recovery. Farmers overwhelmingly approved of the AAA, and the prices of their produce doubled in only three years. Finally, in 1936, the Supreme Court deemed the AAA unconstitutional, and other solutions had to be found. (Courtesy of the Lewis-McKay family.)

The Soil Conservation and Domestic Allotment Act urged farmers to plant clover and alfalfa instead of any of the key commodities. It helped reduce the number of commodities on the market—therefore raising the price of produce—and also aided in conserving the soil traditional farming practices had depleted. This structure would have held corn, a key commodity. (Courtesy of an Almelund resident.)

This photograph was taken around 1930 near Baldwin. During difficult times, such as the Great Depression, farmers have always had a strong community. Mortgage foreclosures during this time hit farmers especially hard. Neighbors were lending money to help bail each other out. The community remained strong, and in Minnesota, laws were passed restricting farm foreclosures. Vigilante groups intimidated bill collectors. No farmer was left to fend for himself. (Courtesy of the Baldwin Public Library.)

Since the beginning of time, it seems, farmers have always had to overcome debt. During the depression of 1893, farmers faced this issue head-on. After the American industrial revolution forged connections between cities, states, and nations, farmers were no longer just competing between neighbors. Railroads connected the nation, and the consumer was no longer constrained to their local market. Food was beginning to be shipped all around the world. Of course, there are positives to this interconnectedness. The St. Croix Valley farmer could now reach farther than ever before. New ideas and farming technology were also beginning to spread. These new techniques increased productivity. An example of a new architectural technique is the round barn pictured below. (Above, courtesy of the Viebrock family; below, courtesy of Mike Tibbetts.)

Overproduction led to a decrease in prices. Farmers tried to counteract this loss by producing more and more, and the cycle continued. Farmers who had taken out loans to pay for more modern farming equipment were finding themselves at a loss. Farm mortgage foreclosures became increasingly common. Boarded up, abandoned farmhouses were everywhere. When Grover Cleveland became the president in 1894, reform and repair began to sweep the nation. Governmental activism began to take hold, and banking reform, as well as the regulation of commercial business, was focused on, but the hot issue was agriculture. The economy was eventually able to balance itself, but in retrospect, it seems as though the depression of 1893 was just a practice run for the Great Depression. (Both, courtesy of the Belisle family.)

While early pioneers faced their own challenges, farmers in the early 1900s were faced with challenges on a bigger scale. Instead of dealing with issues only at the local level, such as this train wreck in Baldwin, world issues began to affect local agriculture. (Courtesy of the Baldwin Public Library.)

## Four

# Logging Industry

History is less of a timeline and more like a web of interweaving events. Many different pieces of the nation's past create a domino effect that ultimately leads to today. Each chapter so far has discussed the effects on today's agricultural practices in the St. Croix Valley. Logging is one component of history that has affected agriculture—and has largely contributed to the success of dairy farming throughout the region. (Courtesy of the John Runk Collection, Stillwater Public Library.)

Logging the white pines in this region was a huge draw. Logging started as a small-scale enterprise. Some loggers squatted on the land, while others owned legal claims. Either way, in the very beginning, the early pioneers who came to log the 250-foot-tall pines were a tough crowd. According to the National Park Service, the logging industry in the St. Croix River valley lasted from 1839 to 1914. It took many different shapes and forms. In many cases, early farmers would work the summer through harvest on the farm, and to earn a living in the winter, many would leave home for the logging camps. (Courtesy of the John Runk Collection, Stillwater Public Library.)

In the 1830s through the 1840s, small logging camps began to sprout along the St. Croix River. The camps remained close to the river, as it proved to be a cheap and easy method of transportation. Lumberjacks would take axes, and later saws, to cut down the tall white pines. Teams of oxen would then pull the logs to the riverbank. The logging outfits were quite temporary—there were shanties built as bunkhouses, supply stores, and mess halls, all roughly built and easily left behind when the tree supply fell short. Despite their rustic nature, many of them thrived in the St. Croix Valley even before settlement. In the article "Logging," the National Park Service states that "in the 1880s there could easily be over 150 camps in the valley during any given winter." The logging industry had a firm grasp on the region's economy. (Courtesy of the John Runk Collection, Stillwater Public Library.)

The St. Croix River, however, had its own ideas about how the logging industry was going to operate. The rocky river at times created a difficult passage for the flow of logs, and the notorious "Angle Rock" proved to be one of the greatest burdens. With the large number of logs flowing downstream, many wound up getting caught, jamming the river. These dangerous jams needed to be prevented. One solution was Nevers Dam, which was built approximately 11 miles north of Angle Rock. This state-of-the-art dam was built in 1889 by Frederick Weyerhaeuser. Nevers Dam allowed for the control of how many logs could be floated down the river, which reduced or eliminated the log jam problem in the area altogether. Weyerhaeuser's plan to create the dam proved to be a tremendous feat for loggers; people could now control the river. With the creation of more intelligent dam building, greater technology, and an influx of settlers in the growing communities, the region's trees were slowly disappearing. When the logging industry began to lose its foothold, the wheat industry began to prosper. (Courtesy of the John Runk Collection, Stillwater Public Library.)

This is a log jam in the Dalles of the St. Croix in June 1886. It was estimated to be approximately 150 million feet of logs. These dangerous log jams are one reason why dams, such as Nevers, needed to be built. This photograph is also indicative of how many logs were passing down the St. Croix River. The once thickly wooded land surrounding the river was slowly becoming claimed by those who could take advantage of the clear-cut land—farmers. (Courtesy of the Somerset Public Library.)

On the back of the photograph above, S.C. Sargent writes, "This load of logs contains 31,480 feet. It is 21 feet high and 20 feet wide. Hauled by four horses, one mile, by the Ann River Logging Co., on the 13th Day of February, 1892." Most of the cutting was done during the winter months, and farmers took advantage of it. Many of the region's early settlers were both farmers and loggers. As soon as the ice melted, the great hordes of logs were released downriver with over 100 owners claiming the logs. The logs were then used to make the region's towns. The photograph at left shows an early post-and-beam framework, revealing that this barn was built before the popularization of nails. (Above, courtesy of the Somerset Public Library; left, courtesy of an Almelund resident.)

The tall pines shown here are being cut to be hauled to the St. Croix River. This deforested land was perfect for early farmers, who benefited from logging in several ways. The harvested tall white pines were phenomenal for building barns, farmhouses, framing, siding, shingles, and more. It was easy to cut, and it floated. The photograph below shows the interior woodwork in an early 1900s barn. The precut white pine was used in nearly every barn in the St. Croix Valley. White pine was also lightweight but hardy and straight-grained. It was the perfect builder's board. (Above, courtesy of the Somerset Public Library; below, Courtesy of an Almelund resident.)

This photograph of the Rivard family was taken near Stillwater. Oxen are carrying fallen logs toward the river. Once the logs reached the river, the so-called "river pigs" would guide them downriver. It was an incredibly dangerous job and drowning was fairly common. As the logs floated downriver and passed various towns and villages, it was such a spectacle that even school would be canceled to watch the river pigs leap across the logs, yelling and guiding them with their pike poles. The logging industry is what fueled each town's economy, and the hundreds of thousands of logs that passed through were a tribute to each town's success. (Courtesy of the Somerset Public Library.)

This is the Wilcox Lumber Company in Baldwin. Hundreds of lumberyards opened during the logging boom. The logging industry was kick-started with the Pine Tree Treaty of 1837. The treaty was signed between the Chippewa and the US government at St. Peters. It opened up the vast St. Croix River valley region for logging and lumbering and forever changed the area for both the Native Americans and the European settlers. (Courtesy of the Baldwin Public Library.)

This is a drawing of Hudson in the early 1900s. The logging industry fueled the growth of towns all along the St. Croix River and its tributaries. It all began in 1837 with the Pine Tree Treaty, but the first commercial sawmill, called the Marine Lumber Company, cut its first log in 1839. Dave Thorson wrote in the article "Jams, Dams, Pines and Pigs" that the first log "was run through their brand new saw on August 24, 1839." Sawmills were scattered along the river south down the Mississippi River, along the St. Croix River in towns such as Stillwater, and along the various tributaries such as the Snake or the Namekagon. (Courtesy of the Hudson Public Library.)

The logging industry affected farmsteading in a variety of ways. It gave farmers a winter occupation, it helped clear the land for agricultural development, and the fallen timber was used to build the farm buildings. Each industry affected the other and created an economic domino effect so that farms like this one could prosper. (Courtesy of a Hudson resident.)

# Five

# WHEAT BOOM

This photograph was taken in 1976 at an unknown location. Barns of this style were scattered across the Midwest and served both the booming wheat industry and dairy farming. The silo pictured here can be considered a fairly recent introduction to farming technology. Early silos went through a series of transitions before becoming what they are today. The earliest silos were pits, often within barns. Later, in the mid-1800s, rectangular silos came into use. This satisfied the farmer's need to store wheat in a dry, easily accessible environment. (Courtesy of the Boucher family.)

The rectangular shape did not allow the smooth descent of grain from top to bottom. Finally, round tower silos, such as this one, came into use in the 1890s. Still, they continued to change. The exterior materials began as wood wrapped with iron bands. Some farmers opted for brick or stone, but this required a mason. Silo-building was revolutionized in the early 1900s when concrete block was introduced. (Courtesy of a Dresser resident.)

Pictured here is a scythe. It is fixed with wooden fingers that aided in gathering the straw as it was cut to be stacked in a swath. American cradle scythes typically had between three to six fingers and had wider blades than a grass scythe. The wide blade allowed the wheat to fall back onto the fingers. The cradle scythes are incredibly efficient; they can cut approximately two acres of wheat per day, and despite mechanization in the early 1900s, scythes were still a popular and efficient way to cut small fields. (Courtesy of the St. Croix County Historical Society.)

Much of the grain was taken to mills, such as the Lake Elmo Feed Mill. Noteworthy events were dutifully recorded in the small rural communities that border the St. Croix River. One such event was proudly recorded in *Recollections of 1876: Polk County's First Written History* and told of Henry H. Newbury, the first Osceola resident to harvest a crop of oats and sell his harvest to the Kent brothers for $1 a bushel. (Courtesy of the John Runk Collection, Stillwater Public Library.)

Over time, farmers changed how the wheat that went into granaries, such as this one, was produced. Before more mechanized threshing techniques, farmers collected wheat using a threshing machine. The workers would first load the stacks of wheat into the thresher. Rotating gears would then separate the stalks from the kernels. The stalks, called straw, would be thrown back out onto the field to be collected for livestock. The wheat kernels would be sent through another sifting area to remove further dust and debris. Finally, the auger would carry the kernels out of the machine and dump them into a wagon for transportation. The inside of a threshing machine is a complicated array of belts, gears, and augers, all for the primary purpose of separating the wheat stalks from the kernels. (Courtesy of the John Runk Collection, Stillwater Public Library.)

Many farmers from the region employed men to help with their farmwork. These hired men would often live in the same home and become close with the family. In an article published by the *Hudson Star-Observer* in 1977, titled "Chronicles of Hudson Prairie," Ben McDiarmid reminisced about his family's hired man. McDiarmid stated, "He was sometimes a relative or neighbor, but more often an itinerant wanderer who, from misfortune or preference, had no permanent home." (Courtesy of the Lewis-McKay family.)

Hired men were the faceless, nameless men who assisted early farmers throughout the year. McDiarmid explained that his hired men "worked on the farms during spring and summer, followed a threshing machine in the fall, then took farmer's horses to the woods in the winter." Despite all the help these hired men offered, many farmers could not remember their names in later years. (Courtesy of the Olesen-Bevens family.)

Pictured above are threshing machines, and below, workers pose for a picture. In "Chronicles of the Hudson Prairie," McDiarmid spoke of his hired man Charlie Bugbee fondly. These men were so integrated into family life that many took part in photographs, family events, and even holidays. McDiarmid stated that Bugbee "could play simple tunes on the harmonica . . . and we would sit on the porch and listen to Charlie play. His favorite tune was 'Little Brown Jug.' I have no doubt that he was familiar with its contents." McDiarmid continued: "Sometimes he would disappear for several days, but when he came back he was always clean and sober." The life of a hired man seemed to be that of a wayward wanderer—at least in Charlie's case. (Both, courtesy of a Hudson resident.)

In the early 1900s, farmers relied heavily on horses to accomplish a variety of farmwork. Pictured is the lower level of a barn that was used to house horses as well as cattle. However, the industry began to change in the 1920s when tractors began to sweep the nation. Tractor use finally peaked in the 1940s. Tractors were efficient, fairly easy to operate, and sped up the harvesting process. However, for early farmers they certainly had their downfalls. Tractors needed maintenance, and more importantly, gasoline. This made them an expensive piece of equipment to operate, so many farmers chose to keep their horses. (Courtesy of the Boucher family.)

According to the local publication *Heritage Areas of St. Croix County*, between 1879 and 1899, St. Croix, Buffalo, and Trempealeau Counties ranked first in the valley in wheat production. The wheat harvested in St. Croix County would often be taken to local gristmills, most of which were powered by the Willow River. (Courtesy of a Hudson resident.)

Martin Bahneman is pictured with his threshing team in Afton. This steam-powered threshing machine was the height of agricultural technology in its time. A stationary steam threshing machine was invented in 1849 by A.M. Archambault & Company. Later, powered wheels and steering were added, resulting in steam-powered threshing machines like the one pictured here. (Courtesy of the Afton Historical Museum.)

Hay is being loaded onto a wagon on Charles Berglund's farm. Behind the wagon is a conveyor belt hayloader. This piece of equipment was still popular in the 1920s, as it proved to be an extremely efficient machine. The hayloader was attached to the wagon, and farmers would rake the wheat onto the conveyor, where it would be dropped into the wagon. This saved farmers tons of time and energy. (Courtesy of the Afton Historical Museum.)

Above is Earl Granberg on his tractor. Tractor machinery has come a long way since the first gas-powered engine was invented. John Froelich invented the gasoline tractor in 1890. This machine could drive only three miles per hour but could thresh roughly 1,000 bushels of grain a day. This was a remarkable feat for early farmers. Froelich went on to create the Waterloo Gasoline Traction Engine Company in 1849, and the company is now owned by well-known tractor manufacturer John Deere. Closer to home, the Northwest Thresher Company out of Stillwater used prison labor in the 1860s to build the steam-powered threshing machines pictured below. George Seymour started the company and brought it to prosperity—all with the aid of the Stillwater Prison. These machines were not only of a high quality but also were cost effective due to the use of prison laborers. (Above, courtesy of the Afton Historical Museum; below, courtesy of the John Runk Collection, Stillwater Public Library.)

A boy is plowing a field on the Berglund Farm in Afton. These horse-drawn plows would prepare the field for harvesting. While the Berglunds were known for growing melons, various vegetables, and onions, this type of plow was common for a variety of crops, including wheat. (Courtesy of the Afton Historical Museum.)

Despite the common assumption that St. Croix County's chief enterprise was logging during the 1850s, it was actually farming that drove much of the economic success in the region. This success kick-started when Congress passed the Preemption Act in 1841. This gave squatters the first chance to purchase the land they had been illegally utilizing for an undercut price of a $1.25 per acre. (Courtesy of the Afton Historical Museum.)

Ma[?], far[?]ers purchased land that was already cleared by loggers and planted wheat, which fit their bus[?]es. These grub prairies were planted with wheat, often before all the tree stumps were removed, since wheat is a low-maintenance crop that needs little attention from a busy farmer. (Courtesy of the John Runk Collection, Stillwater Public Library.)

Frank and Betsy Ross of Afton are pictured on top of a hay mound. Their hired man is holding their son Orville on the hay wagon. The horses are draped in netting to keep off the flies during the long workday. One goal of haymaking is to ensure the hay stays dry. A way to ensure this is to leave the hay stacked or mounded in open fields. The Rosses are likely storing their hay loosely in the barn for animal use, where it could stay fresh for about three years. (Courtesy of the Afton Historical Museum.)

Above, a farmer is utilizing a walking plow. Common walking plows were typically pulled by horses, as pictured here, but also by mules and oxen. John Jethro Wood is noted to have invented the first widely used plow, which was patented in 1819. These small, self-sufficient operations grew along with their communities. Stillwater, for example, had several feed mills such as the one pictured below. (Above, courtesy of the Afton Historical Museum; below, courtesy of the John Runk Collection, Stillwater Public Library.)

Above are hay mounds piled high in the field. This photograph was taken in an unknown location but is still representative of the hay mounds in the St. Croix Valley. The high production of wheat led to the growth of gristmills along the St. Croix, Willow, Kinnickinnic, and Apple Rivers, and other small tributaries in St. Croix County. The mill below is located in Somerset. The first gristmill to be built in the county was the c. 1853 Greene's Paradise Mill on the Willow River. The mill's proud owners were Caleb Greene and Charles Cox. Soon after, dozens of other mills were scattered along the countryside. In 1868, Christian Burkhardt's mill was erected in a town that was later named after him. Burkhardt's mill was the first electrically powered mill in Wisconsin, arguably the first in the United States. (Above, courtesy of the McKay-Lewis family; below, courtesy of the Somerset Public Library.)

The necessity of flour in early settlers' lives was apparent in many ways. The cloth bags used to hold flour served many household purposes, such as clothing and rags. In 1872, Bailey and Bartlett created a sawmill and flour mill operated by steam power in Baldwin. The men seen here are from Baldwin at the Empire Flour Mill in 1800. (Courtesy of the Somerset Public Library.)

The farmers above are using an Aultman Taylor theshing machine, and the Rivard family threshing party is shown below. The St. Croix Valley, as in much of the United States, experienced a transition to more modern farming technology to accommodate farmer's needs. (Both, courtesy of the Baldwin Public Library.)

This photograph was taken of the Parent, Cross, Germain, and Dumais families of Baldwin in 1893. The wheat boom in the St. Croix Valley allowed farming families to prosper. The rather sudden economic success, however, tended to conceal the larger economic and environmental issues that loomed. (Courtesy of the Somerset Public Library.)

Four men are pictured inside a Baldwin mill between 1945 and 1950. The wheat boom affected St. Croix Valley culture and economy until its subsequent crash near the turn of the 20th century. Agriculture in the region continued to evolve as science and the socioeconomic environment of the early 1900s began to take leaps and bounds forward. (Courtesy of the Baldwin Public Library.)

## Six
# GROWING COMMUNITIES

While today there is still a sense of community, the bond between neighbors is not typically over agriculture. (Courtesy of the Baldwin Public Library.)

William Ellmann, a well-known barn-builder during the early 1900s, balances on a beam. Suburbs have popped up where sprawling wheat fields used to be. Proud, whitewashed farmhouses have begun to sag, and the red barns that were once their proud neighbors have begun to sink pitifully back to the earth. Despite this, there are still farmers proudly feeding America using the barns built by their ancestors. It is certain that the St. Croix Valley's farmers are a hardworking group of Wisconsinites and Minnesotans. (Courtesy of the Afton Historical Museum.)

*Compliments of Midwest Breeders*

Here is a postcard from the Polk County Fair. The fair has been enjoyed since the 1890s. Besides the food and rides, the barns have been one of the largest attractions. The barns provide a venue for local farmers to showcase their prized crops and animals. (Courtesy of the Boucher family.)

Community events and fairs in the St. Croix Valley often highlight agriculture. Many of the agricultural traditions have been preserved and remain in practice today, such as dairying celebrations, tractor pulls, strong 4-H communities, and farmers' markets. (Courtesy of the Baldwin Public Library.)

Pictured at right are Michael (left) and Patrick Boucher in 1976. They had just finished participating in a yearly family event—the Osceola Tractor Pull. Small towns, like Somerset (below), often bring rural residents together using a common interest—tractors and healthy competition. Michael and Jolene Boucher eventually took over the farm in 1994, and the barn is still in operation today. However, due to changing agricultural demands, the cattle size has dropped significantly, and the silos are no longer in use. Larger barns with bigger facilities outcompete the smaller, family-owned farms. Still, these annual community events keep farming traditions alive. (Right, courtesy of the Boucher family; below, courtesy of a Hudson resident.)

Pictured above is one of the many early ferryboats that carried travelers on the St. Croix River. The steamer *Pauline* was built in Stillwater in 1879 for Durant, Wheeler, and Company. Many of the best-known steamboats on the St. Croix and Mississippi Rivers were built in Stillwater. As communities grew and technology changed, automobiles became the primary method for travel. Pictured below is the Hudson Toll Bridge, which operated from 1913 to 1951. (Above, courtesy of the John Runk Collection, Somerset Public Library; below, courtesy of the Baldwin Public Library.)

The unique territory of early St. Croix County meant that much of its history actually blends with Minnesota. It was not until Wisconsin became a state in 1848 that the western boundary of Wisconsin became the St. Croix River. The boundaries continued to shrink until 1853, when St. Croix County's borders started to look similar to what they are today. The second half of the 19th century is when St. Croix County began to boom, and the population increased dramatically. Towns such as Hudson (1840), Somerset (1856), New Richmond (1857), Baldwin (1871), and many others began to flourish within the county, and between 1860 and 1870, the population doubled. This photograph was taken on the Minnesota side looking into Wisconsin. (Courtesy of the Baldwin Public Library.)

Wisconsin and Minnesota communities began to flourish in the mid- to late 1800s. Roads were built, tracks were laid, and businesses prospered. While rural farmers may have been miles from town, their connections ran farther than one might think. The Lewis-McKay family has a certificate of sale for selling the first two-ton steer to the St. Paul Stockyards. Charles Ward owned nearly 2,000 acres of land and was revered throughout the country. The St. Croix Valley has seen cheesemakers and dairy farmers share their quality products and expertise in Europe, Africa, and Asia. These small-town farmers were recognized worldwide by the first half of the 20th century, an incredible feat. (Courtesy of the Baldwin Public Library.)

# Seven
# DAIRYING AND BERRIES

The wheat boom and the communities it built could not carry on forever. As economic and environmental demand changed, farmers began to transition to dairy farming, a practice that still strongly persists in the St. Croix Valley today. (Courtesy of the Baldwin Public Library.)

Wheat began its decline due to over-cropping, the lack of crop rotation, and chinch bugs, smut, and other diseases and pests. Wheat farming was beginning to move west, but it did not solve the immediate problem farmers still faced in St. Croix County, which was how to put food on the table. There had been talk for years and action had to be taken, and dairy farming was the next best option. Above is an aerial photograph of Victor Martel's farm in the 1960s; below is the Olesen-Bevens farmhouse, which was removed from the property in recent years. (Above, courtesy of the Martell family and the Somerset Public Library; below, courtesy of the Olesen-Bevens family.)

The dairy cow, once widely known as the second-class occupant grazing in the backyard, began its climb up the agricultural ladder. Many of the valley's farmers turned to butter production. There were high-grade butters and low-grade butters. The low grade was referred to as "western grease" because that was all it was good for. Quality control was often impossible, and high-quality butter was too difficult to achieve until the De Laval Cream Separator was invented. The separator helped ease the process of buttermaking for early farm women. (Above, courtesy of the Baldwin Public Library; below, courtesy of a Shafer resident.)

This is the Berglund brother's farm in Afton. With every turn of a century, there are always those who want to revolutionize the dairy farming business. Even George Washington was seeking ideas to more effectively tend his dairy cows and make farming life easier. The drive to make everyday life easier for dairy farmers set in gear a wide range of farming practices and barn architecture. (Courtesy of the Afton Historical Museum.)

Many barns were built with the idea of remaining economical yet more effective for holding livestock. The Viebrocks near Osceola now own the round barn seen here that was designed for the purpose of both catering to the shape of cows and to be more economical. From the 1890s to the 1920s, round barns were at the height of their popularity. Contemplating the shape of a cow seen from above, it is apparent that they are shaped somewhat like a piece of pie. The head is the smallest part of the body, which slowly widens out toward the back. The idea behind round barns was to fit more of these animals into a space. The cow's head would face the center silo, and the rear end would face the outside wall. (Courtesy of the Viebrock family.)

Some farmers also opted for round barns because it was believed they required less material to build than a traditional rectangular barn. Many people also believed that the wind would more effectively go around a round barn, hopefully sparing it during a storm. Jodi Henke, author of the article "History of Round Barns," explains, "The round barn was built for dairying, and not as useful for other types of agriculture. The popularity of round barns ended by the 1920s." Traditional barns have remained the popular choice. (Above, courtesy of the Viebrock family; below, courtesy of a Balsam Lake resident.)

Martin F. Bahneman emigrated from Martinsville, New York, to Afton in 1865. Eventually, Bahneman purchased a sawmill in 1872, cut it in half, and transported it to his homestead. The mill was reassembled on a limestone block foundation, similar to the one shown here, and used as the family barn. The barn was torn down in 1979, but it has a unique story and is certainly not a "run-of-the-mill" tale. (Both, courtesy of a Shafer resident.)

Most round barns brought to this region were the result of religious communities, like the Shakers. The center silo was used for grain storage or was sealed in order to ferment grain for silage. Wagon access was at the ground level, and the livestock was kept underneath. The round shape made cleaning easier and prevented animals from cornering themselves. (Courtesy of Mike Tibbetts.)

Pictured here is the Lewis-McKay family in 1930. Behind them is the original barn built approximately in 1856. This barn's architectural style is quite similar to the basement barn style. These barns were incredibly efficient by maximizing space for both livestock and grain processing. A bank leading to the upper floor made it easy for farmers to drive wagons onto the upper level, while the basement could still be accessed on the ground level, usually on the broad side. This made it easier to usher cattle in and out of the stalls. (Courtesy of the Lewis-McKay family.)

In the late 1800s, precast concrete held by metal bands began to grow in popularity as a modern alternative to wood structures. Eventually, a fiberglass silo was introduced after World War II, with the widely known name of Harvestore. While concrete silos are still in use today in the St. Croix Valley, there is a blend of the blue fiberglass silos and the dated concrete structures. A benefit of the Harvestore is better insulation and easier emptying, but both silos served the same purpose of feeding cattle. (Above, courtesy of the Somerset Public Library; below, courtesy of the Baldwin Public Library.)

The St. Croix Valley is also home to German bank barns. These barns, as indicated by the name, were built into banks. This helped ease labor during building, as the bank would function as three-quarters of the basement level, with one side open to allow access to wagons and other farming equipment. A forebay would extend over the basement, and in larger barns, extended two or three floors upward. However, there were not many banks in the area, and German settlers needed to adapt their barn style to their environment and to their growing farm size. Germans are widely credited for the creation of the Wisconsin dairy barn. As can be seen in much of the St. Croix Valley's countryside, large gambrel-roofed barns with ventilators and dormers became the local adaptation of the traditional German barn style. (Courtesy of the Baldwin Public Library.)

Donna Seim proudly shared this newspaper clipping of her barn during her interview. The beautiful silhouette highlights its gambrel roof and ventilator. During war, barns were often a symbol of home and family—just as they were symbols of progress, community, and hard work. Donna recalls when her husband returned from the Korean War. When he was plowing, some loud noises or airplanes flying overhead would cause him to "grip the steering wheel on the tractor so tight he had white knuckles. [Some noises] would remind him of a mortar coming in . . . and he'd have to tell himself he didn't have to jump in a foxhole." Donna recalled that Tom had to go through a difficult adjustment period, but the farmwork proved to be a distraction. (Courtesy of Donna Seim.)

Adaptations were also made as people discovered how to make building barns easier and more standardized. Around the turn of the 20th century, many barns began to change in style due to easier building methods and the simpler transportation of materials. Wood began to be cut into standard sizes at sawmills, and the advent of metal nails replaced the post-and-beam framework that had to be pegged together by hand. Balloon-framing was a simpler method that took smaller pieces of wood and nailed them together, such as the barn pictured here. Instead of framing in each floor separately, builders could extend a stud to the full height of the barn. This method was far easier and more economical. (Courtesy of the Olesen/Bevens family.)

Farmers also had to consider the size of their livestock when building their barn. In the earlier stages of barn building, the length of barns was typically a multiple of eight or sixteen feet. A "short yoke" would fit two oxen and required a length of eight feet of stall room. A "long yoke" would fit four oxen and required a length of 16 feet of stall room. As more and more farms in this region became successful, a standard size of 16 feet became the normal length of boards used to build a barn. Factories made standardization of boards commonplace. The barn pictured above was built to accommodate horses. (Above, courtesy of the Olesen/Bevens family; below, courtesy of the Hudson Public Library.)

Farmers also personalized their barns to fit their habits and needs. Livestock was typically kept on the ground level to make cleaning and the movement of animals in and out of the barn easier. On this level, there would be troughs and stalls designed for dairy cattle and trenches that would hold manure until it was shoveled out. The second floor was for grain storage, and a large chute would often be put in the floor so that silage could be thrown to the lower level and fed to livestock. This barn style is typical of the Wisconsin dairy barn design and was so practical that it spread further into the West and even gained some popularity in the East. (Courtesy of the Lewis-McKay family.)

This beautiful barn silhouette was photographed by Donna Seim before the barn was taken down around 1986. The leftover foundation was buried in 2000. Throughout this barn's lifetime, it saw improvements such as an automatic barn cleaner and a hay elevator. Naturally, every technological improvement also had its fair share of setbacks and problems. Donna reminisced about the oats and grain chute her daughters were fascinated with as children. Feed was shoveled down a chute from the upper level to the lower level of the barn and into a wheelbarrow to be fed to the cattle. The chute may have been fascinating to her children, but her husband, Tom, had to remind them of the dangers of falling in. Children raised on farms often grew up with a heightened sense of responsibility and awareness of their surroundings. (Courtesy of Donna Seim.)

This photograph was taken in 1951 of the Seim family. Before Donna (wearing the plaid coat) and Tom had owned their farm together, Donna had some experience working on a farm. She reminisced of visiting her grandfather's farm near Landing Hill. Donna said, "When Grandpa was putting cows into the barn my brother and I were told to go up and stand by the hay barn door and look through the barn window and when we saw the bull . . . go in his stanchion we could come down." Donna chuckled and continued, "We saw the bull go through the door and we thought, you know, by the time we got down there and around he'll be hooked up. Well, the dog was with us. The bull saw the dog and instead of going the rest of the way in he turned around and came back out. He chased the dog and us back up the hill. We got scolded big time from Grandpa." (Courtesy of Donna Seim.)

Tom Seim is pictured near a favorite childhood hangout, his grandparents' farm on Perch Lake. The barn that Tom would later purchase in his adult years was reminiscent of the other barns he was probably surrounded by as a child. The barn was similar in style to the Wisconsin dairy barn, primarily built during the booming dairy industry of the early 20th century. (Courtesy of Donna Seim.)

This c. 1960 photograph shows Duane Boucher performing his afternoon chores feeding the chickens and pigs. He is pictured here carrying two buckets of chicken feed. Duane purchased the family's first tractor after he acquired the farm. It was a Farm-All H, which the family still uses every day. Duane also expanded the farm by adding a silo and doubling the barn in 1976. The Boucher barn had a steel roof that was installed in 1958—making it one of the first barns in the area to upgrade to modern roofing materials. This, however, was not done by choice. The hay barn had caught on fire in 1958. Luckily, the animals and the majority of the lower barn was intact, but the hay barn needed repairs. The steel roof was a cost-effective and durable choice. (Courtesy of the Boucher family.)

Norval and Edith Boucher enjoyed the farm for 42 years before it was passed down to their son Duane. The Village View Dairy Barn was taken over by Duane and Jeanette Boucher in 1967. On the far left, Duane's brother Roland is pictured with his two sons Terry and Donny in the wagon. Duane is likely taking the photograph, as he seemed to be the photographer of the family. Jeanette is seated on the blanket, and the two girls are unidentified. Behind them is the family farmhouse, which was built in 1863 and updated in 1911. It has continued to be updated since then. (Courtesy of the Boucher family.)

Mary McKay's grandmother is seen here milking a cow at the farm. Dairy farming slowly rose in popularity in the region after the wheat boom came to an end. Many people who had referred to their cattle as "second-class citizens" now bit their tongues. Dairy farming became a profitable enterprise in the region, and cows moved their way up the social rankings. The sale of well-bred cattle was a source of pride. (Courtesy of the Lewis-McKay family.)

The original Getschel barn was erected around 1900. Eventually, the demand for butter, and of course Wisconsin's staple treat, cheese, increased. Cheese factories and creameries sprinkled the county. The advent of large commercial enterprises with alternative storage and transportation techniques caused many of the cream and cheese factories in the valley to disappear. As agricultural demands shifted, the gristmills began to fade, and through time, the traditional family farm has begun to disappear from the region as well. (Courtesy of the Getschel family.)

The Lewis-McKay family of Hudson, seen here, had more of a multipurpose farm, while other farmers would focus on a specific crop or product. Some communities became known for a specific product, such as Afton, which was well-known for its berries. Farms such as Swan Peterson's, Oak Grove Farm, Mayfield Nursery, and Brigg's Produce Farm all made their success in berry farming. (Courtesy of the Lewis-McKay family.)

Charles Gustaf Berglund, native of Sweden, arrived in Afton in 1871 and started working as a shoemaker in the lumber camps in Stillwater. Eventually, he transitioned into farming, and he and his wife, Marta Lisa, owned the Oak Grove Farm, pictured here. The farm blossomed and was known for its various vegetables, melons, and onions and for its onion barn. This spectacular barn was 56 feet long with three upper floors used for drying and storing the harvest. Oak Grove Farm was also well-known for its strawberries. In 1927, it sold and shipped 63,000 strawberry plants to growers in Iowa, the Dakotas, throughout Minnesota, and Wisconsin. (Courtesy of the Afton Historical Museum.)

The Mayfield Nursery also has a unique story. Louis Lovell May started the nursery in 1899. During the height of the nursery, he had approximately 125 employees during the summer months. May also holds the proud title of being the first tree nursery in Minnesota. His passion seemed to be based more on a scientific approach rather than standard farming. He experimented with various types of trees to explore which species would grow best in Minnesota. His results introduced Siberian maples, New England pitch pines, and Tatarian maples. Tatarian maples now dot the entire countryside. The 240-acre Mayfield Nursery was also home to several other of May's experiments; he also specialized in shrubs and trees that could be used as windbreaks. His careful studies helped introduce plant species that aided other farmers and homeowners. While driving down a back road or hiking through the woods, it is still evident today that May was successful in his endeavors. (Courtesy of the Afton Historical Society.)

Afton's agricultural accomplishments were recognized even in Washington, DC. William Lofgren sold two purebred bulls to the federal government. Those bulls were shipped from Afton to China to help improve cattle strains. But just like other farms across the region, Afton's agricultural economy changed over time. Barns either changed use, were torn down, or were left to crumble. It is impossible to point to just a few reasons why family farming has changed. Each family is unique, each region has its reasons, and each barn has its own story. (Courtesy of a Hudson resident.)

Three children are seen here playing at the Lunsmann farmstead. Dairy farming in the St. Croix Valley can be best described by local Donna Seims: "It was a lot of counting to ten." She continued, "Farming was great for raising a family. Of course, you had cats on the farm and the cats when it was time to have babies always went up in the hay barn. So then my girls would get whoever was working here to talk him into helping them get the kittens out. . . . When they were younger they mostly just got in the way." However, as the girls got older, they began to receive more responsibilities. The mailman would deliver baby chickens and the girls would be responsible for treating the chicks, feeding the calves, and of course, helping Dad drive the tractor. (Courtesy of the Olesen-Bevens family.)

Pictured is the Lunsmann farmstead. Donna Seim listed some of the farming troubles during the winter season. She mentioned that the automatic barn cleaners were "a headache in themselves. In the wintertime, they used to freeze up, he [Tom] would try to break the frozen manure so the thing would go again, because it would go out through the gutters and in an elevator and out to the spreader. And of course, you'd go out into the field with the spreader and something broke down and it froze up on you, you know?" (Courtesy of the Olesen-Bevens family.)

## Eight
# FARMING TODAY AND PRESERVATION EFFORTS

Whatever the reason why farmers have chosen to or have had to quit farming, their stories and their history are important to pass down. Hope still exists in preservation efforts. Despite these efforts, many of the early barns and pieces of the region's agricultural past are beginning to disappear. Preservation efforts in the St. Croix River valley have been made. However, these strides toward preservation are few and far between. (Courtesy of an Almelund resident.)

St. Croix Valley experienced multiple economic shifts. From early French fur trading to logging, wheat farming, and then dairying, this region seems to have experienced it all. Today, more and more people are beginning to realize that the dynamic of early farming has changed drastically. Aerial views are a fantastic way to see how farms have changed over time. Both the Getschel farm (above), purchased around 1887, and the Shafer farm (below), built around 1907, have changed throughout the years. (Above, courtesy of the Getschel family; below, courtesy of a Shafer resident.)

Pictured here is Tom Seim, Donna's husband, as a child. His grandparents owned a farm in Perch Lake that he looked forward to visiting every summer. Tom grew up around Oak Park Heights, Minnesota, and used to ride his bicycle all the way over to his grandparent's house every summer. When he reached adulthood, the interest in farming stuck, and he purchased his own farm nearby in 1958. As the economic climate in the area changed, Tom and Donna realized that the availability of farmhands had begun to slowly diminish. The vast responsibilities of taking care of a farm were too heavy for the wages they were earning. The Seims decided to pursue other career paths. Still, to this day, Donna continues to educate the public, especially through the local schools, about early pioneer life and historical agriculture. (Courtesy of Donna Seim.)

When trying to discover one or a few main reasons why the barns of this region have been disappearing from the landscape, each farm tends to have its own blend of reasons. Some barns are left behind because the occupants passed away and there was no one willing to take on the huge responsibility of maintaining a farm. Traditionally, farming is an inherited career. (Courtesy of the Olesen-Bevens family.)

Many are deterred by the fact that farming is not a career of wealth. Other local farmers have mentioned changes in the agricultural economy and the need to either quit farming completely and move on or change the dynamic of their farm. For example, many barns in the region have transitioned into rustic wedding venues. (Courtesy of a Shafer resident.)

Edward Hoogterp, author of the article "Working Assets for Sustainable Farms," points out a couple of key issues modern farmers are facing. The old barns may be architecturally pleasing; however, "The buildings were designed for a time when farm power was supplied by animals or by very small tractors." (Courtesy of an Almelund resident.)

The farmhouse pictured here, along with its barn, are no longer standing. There are numerous reasons to keep barns. There are barn preservation groups and many modern farming techniques that can still make use of the traditional barns that dot the countryside. Hoogterp mentions several ways farmers can make use of their barns and other outbuildings on the farmstead, including "egg production, grain storage, retail space, vegetable packing, machine shops and other purposes, in addition to livestock shelter and hay storage." (Courtesy of the Olesen-Bevens family.)

The phrase "sustainable farming" has become increasingly popular, and for good reason. Sustainable farms that continue to use the traditional barns help support the local economy, provide more humane treatment of their livestock, promote their communities, have more diverse farms, and are more health-conscious in regards to their use of fertilizers and hormones. (Courtesy of a Hudson resident.)

Hoogterp outlines five economic benefits for farmers to restore and maintain a traditional barn: cost, energy efficiency, scale, organic uses, and marketing possibilities. Pictured here is an inscription on a barn's center silo that reads, "R.L. Lindstrom." The Lindstroms homesteaded this farm in 1913. Barns such as this one have been maintained for ongoing, modern-day use. Simply put, old barns were built to last and built smart. (Courtesy of Mike Tibbetts.)

This is what is called a "honey wagon." An intelligent piece of farming equipment built into round barns, this wagon ran along a track fixed to the ceiling. As farmers were cleaning the gutters, manure could be shoveled into the honey wagon and taken down the track and right out the door. The current owner is working to restore this barn to its original condition but has run into a large problem: the old roof sprung a leak. The barn was built around 1918. (Courtesy of Mike Tibbetts.)

Donna and Tom Seim and their three daughters, raised on the family farm since 1958, experienced a different form of historic preservation for their barn. Much like the barn pictured here, their barn began to slowly fall apart from disrepair. (Courtesy of a Shafer, Minnesota, resident.)

The Seims' sagging barn had caught someone's eye on Easter around 1986. A gentleman approached the home and asked the family if he could take down the barn to use its wood for a retirement home. The Seim family agreed to his proposal. A Shafer resident said the barn pictured here was often pursued for barn wood. While the barn no longer serves its original purpose, this method of repurposing collapsing barns has become quite popular. The original foundation of the Seim barn has since been buried. (Courtesy of Donna Seim.)

The Lewis-McKay Century Farm is an example of impeccable preservation and dedication toward maintaining a piece of Wisconsin history and family heritage. Mary McKay and other descendants of the ancestral homesteader Daniel Lewis take part in a limited partnership to maintain the historical integrity of the farm. The most fascinating piece of their preservation project is their barn. Daniel Lewis homesteaded this piece of Wisconsin heaven in 1854. (Courtesy of the Lewis-McKay family.)

Like many other homesteaders in the region, Lewis had come as an aspiring and hopeful immigrant. He was from Wales and had come to Hudson to participate in the booming logging industry. After spending about five or six years logging, Lewis was itching to revisit his agricultural past. With the determination of many of the early pioneers, Lewis finally started to seriously farm in approximately 1856. Seen here is the Dray Line in Hudson, which carted goods short distances and proved helpful in rural and growing communities. (Courtesy of the Hudson Public Library.)

Around the time Lewis started farming, he also built a beautiful barn to hold his livestock and hay. The barn was a central part of their lives until 1936, when the last inhabitants of the home passed away. The farm luckily remained in family hands, but because it was not occupied and steadily maintained, it slowly began to fall apart. Tired beams began to weaken. The roof sadly sagged in. A sentiment among farmers explains why these barns seem to fall apart after only a year or two of being empty. According to Mary McKay, "I think that maybe they lose their heart, you know?" The Lewis-McKay barn had done just that. (Both, courtesy of the Lewis-McKay family.)

Finally, in 1982, Mary's mother, Mary Esther McKay, opted to restore the home and barn to their original vigor. The project was an enormous undertaking. The barn was completely dilapidated. Squatters had frequented the area, and surprisingly, they found a large amount of marijuana being grown in the field below the house. In time, the house was completely restored, but the barn was too far gone. The McKay-Lewis family opted to replace the original barn with something new, but not quite "new" in the sense of being a modern build. Working with an architect, the family was able to locate and rebuild an old barn from another Wisconsin property and rebuilt it piece-by-piece on top of the original barn's foundation. The build was an incredible feat; each board needed to be numbered and placed in the exact same spot. However, it is evident that the work was not wasted. The "new" barn matches the facade and historical integrity of the original barn and is simply a beautiful piece of architecture. (Both, courtesy of the Lewis-McKay family.)

> I am so relieved to know that The Barn has been bought by someone who appreciates it! And my client and I will be delighted if you should decide to make it available to her. We have just completed the rehabilitation and restoration of her National Register farmhouse, and she would very much like to replace the barn which was lost to vandals about five years ago.
>
> But if you decide to keep it, we would very much appreciate your keeping an eye out for another like it which she could get. And we would appreciate your expert advice and help on dismantling and moving and reassembling.
>
> I am glad you know and presumably use the services of Foster Dunwiddie. I preceeded him as Preservation Officer for this area, but that was in the bad old days before old buildings were being appreciated, and the loss of the Metropolitan Building was a catastrophe from which I have never quite recovered.
>
> Do keep us in mind. Thank you.
>
> Yours sincerely,

Barns and their small-town dairying partners, such as the one seen here, went from single-family operations to largely commercial enterprises—and the old, traditional barns that were built for holding around 30 animals could not keep up with growing demands to commercialize agriculture. Large tractors, increased use of specialized farming equipment, increasingly large cattle, and the profound amount of swine and chickens, all advocated for the movement away from traditional barns. Traditional dairy barns simply cannot fit what a modern farm needs to operate. (Courtesy of the Baldwin Public Library.)

Traditionally, agricultural goods did not travel far. In the St. Croix Valley during the late 1800s and into the early 1900s, it simply was not an option to transport produce very far. The following notable accomplishment was documented in the local publication *Heritage Areas of St. Croix County*: local farmer Samuel T. Merritt was reputed to be the first resident to ship wheat as far south as Lacrosse. After its arrival in Lacrosse, it was converted to grain or flour and shipped throughout the United States. As technology evolved, it became far more common to transport goods longer distances, and the way people chose to feed fellow Americans changed. (Courtesy of the Hudson Public Library.)

Our communities have grown. Pictured here is the old Hudson Toll Bridge in 1945. Compared with Interstate 94, this bridge is miniscule. Interstate 94 cuts through swaths of farmland. Awareness of what has been lost can put preservation and agricultural history and appreciation back in the forefront of minds. (Courtesy of the Baldwin Public Library.)

The public could easily be described as disengaged from agriculture. It was once a vital part of the economy, and rural America today almost seems like a foreign place. Understanding the local agricultural history and valuing the farmers can help raise awareness for the forgotten workers of America. (Courtesy of the Somerset Public Library.)

Wisconsin continues to lose one barn a day. With each barn lost, each farmhouse abandoned, and fields grown over, the St. Croix Valley loses a piece of its history. Agriculture has been a valuable part of this region's economy, culture, and community. While the world around is changing, it is important not to forget those who developed communities in the very beginning. (Courtesy of the Viebrock family.)

# Discover Thousands of Local History Books Featuring Millions of Vintage Images

Arcadia Publishing, the leading local history publisher in the United States, is committed to making history accessible and meaningful through publishing books that celebrate and preserve the heritage of America's people and places.

## Find more books like this at
**www.arcadiapublishing.com**

Search for your hometown history, your old stomping grounds, and even your favorite sports team.

Consistent with our mission to preserve history on a local level, this book was printed in South Carolina on American-made paper and manufactured entirely in the United States. Products carrying the accredited Forest Stewardship Council (FSC) label are printed on 100 percent FSC-certified paper.

**MADE IN THE USA**